Childe Hassam
in Indiana

Childe Hassam
in Indiana

Alain G. Joyaux

Brian A. Moore

Ned H. Griner

Ball State University Art Gallery

November 3–December 8, 1985

This exhibition at the Ball State University Art Gallery and its accompanying publication were made possible by a generous grant from the Indiana Arts Commission with the cooperation of the National Endowment for the Arts. Additional support has been provided by the Institute of Museum Services, a federal agency that offers general operating support to the nation's museums.

IIAC⊕

With the support of the
Indiana Arts Commission and the National Endowment for the Arts

Ball State University Art Gallery
Muncie, Indiana
November 3–December 8, 1985

Miami University Art Museum
Oxford, Ohio
January 11–March 16, 1985

Cover
Cliff Rock, Appledore
Indianapolis Museum of Art
Catalogue no. 7, p. 37

Contents

Acknowledgments

The Ball State University Art Gallery, made possible by a gift from the Ball family, has been a vital part of the cultural life of the Muncie community for more than half a century. By 1928 the college and community collections occupied a modest gallery incorporated into the school library. The present building, designed by Indianapolis architect George Schreiber, was dedicated on May 1, 1936. The building's classrooms were first used during the fall of 1935.

The celebration of the fiftieth anniversary of the Ball State University Art Gallery during the 1985–86 academic year is a momentous occasion. Yet, as we celebrate this milestone and look toward a second half-century of service, it is also particularly appropriate to re-examine our past. The gallery has historically been the beneficiary of support from a unique college and community partnership. In this same partnership lies its future.

What type of exhibition would honor this exemplary history of support, highlighting our own collections as well as having significant effects statewide? What kind of show would carry forward the tradition of excellence established by the gallery's inaugural exhibition of eighteenth-century French paintings from the Wildenstein Gallery? These are questions not answered easily. Yet an answer was found in Childe Hassam.

It is rare to find a significant body of work representative of all phases of the career of an artist of international acclaim outside the major art centers of the world. The state of Indiana is indeed fortunate to have such a representation of Childe Hassam in its public collections, and *Childe Hassam in Indiana* unites this wealth of material for the first time.

The literature on Childe Hassam and the Impressionist movements in France and America is extensive. This exhibition does not attempt to expand this body of scholarship. It strives instead to place accurately those works housed in Indiana public collections within the broader context of his life and era. Lengthy histories of ownership and documentation of exhibition histories and references are provided to enable this publication to serve as a *catalogue raisonné* of Childe Hassam in Indiana. We hope that this exhibition and publication will lead both scholars and the general public to re-examine the history of the arts in Indiana during the initial years of this century. Therein lies the cornerstone of the future.

Loan exhibitions make substantial demands on museums and, because of the specific nature of this exhibition, we were confined to a set group of works. It is thus particularly unfortunate that there was one painting that could not be included in the exhibition. In the interest of completeness, it is nonetheless fully documented herein.

For their generous cooperation in lending the works that are included in this exhibition, I should like to express our gratitude to Douglas Bakken, executive director, Ball Brothers Foundation; A. M. Bracken, George and Frances Ball Foundation; Richard Brauer, director, Valparaiso University Art Galleries and Collections; Emily S. Kaas, director, Fort Wayne Museum of Art; Ruth B. Mills, director, Whitewater Valley Museum of Art; Dean A. Porter,

director, The Snite Museum of Art; John W. Streetman III, director, Evansville Museum of Arts and Science; Thomas T. Solley, director, Indiana University Art Museum; and Robert A. Yassin, director, Indianapolis Museum of Art. I should also like to thank the lenders for allowing their works to travel to the Miami University Art Museum and for making possible the subsequent tour of the prints portion of this exhibition within the state.

The funds necessary to bring *Childe Hassam in Indiana* and the accompanying catalogue to fruition have come from a variety of sources including Ball State University and the Friends of the Art Gallery. Important grants were received from the Indiana Arts Commission and the Institute of Museum Services. For their support of this endeavor, I express my sincere appreciation.

To the following persons and institutions who, over the past twelve months, have been the source of pertinent data, offered encouragement and patiently answered inquiries, I should like to express my genuine thanks: Linda Ashcraft, Lydia Barts, Jane Burns, Kathleen Burnside, Ned Griner, Jane Joyaux, Marty Krause, Terry Larkin, Ellen Lee, Ted Moore, Mary Schnepper, Stephen Spiro, Anne Stellwagon, Shirlee Studt, Jeffrey Weidman, the Archives of American Art, Smithsonian Institution, the Clarence Ward Art Library, the Michigan State University Libraries, and the A. M. Bracken Library, Ball State University.

No exhibition can be realized without the cooperative efforts of many people. For their important contributions to the success of this exhibition, I would like to thank the staff of the Ball State University Art Gallery, the Friends of the Gallery, and the Art Gallery Alliance. I should like to make particular mention of Brian Moore, who has cooperated on many aspects of the exhibition and prepared both the catalogue and the insightful essay on Childe Hassam's prints; of Donna Browne, who oversaw this publication from handwritten notes to edited typescript; of Ned Griner for sharing his painstaking research into the history of the visual arts in Muncie; and of Richard Wattenmaker for his valuable insight into the Impressionist era. The production of the catalogue was the result of the substantial efforts of the Office of University Publications.

Finally, to those patrons of the arts, collectors, and institutions who have, over the past one hundred years, formed Indiana's public collections, I should like to express my deepest appreciation for their indispensable contribution to *Childe Hassam in Indiana*.

Alain G. Joyaux
Director
Ball State University Art Gallery

List of Lenders

Ball Brothers Foundation
Muncie, Indiana

George and Frances Ball Foundation
Muncie, Indiana

Ball State University Art Gallery
Muncie, Indiana

Evansville Museum of Arts and Science
Evansville, Indiana

Fort Wayne Museum of Art
Fort Wayne, Indiana

Indiana University Art Museum
Bloomington, Indiana

Indianapolis Museum of Art
Indianapolis, Indiana

Indiana State Museum
Indianapolis, Indiana

The Snite Museum of Art, University of Notre Dame
Notre Dame, Indiana

Valparaiso University Art Galleries and Collections
Valparaiso, Indiana

Whitewater Valley Museum of Art (Art Association of Richmond)
Richmond, Indiana

Introduction

The Impressionists introduced painting to the open air, to the study of changing effects in nature according to the innumerable conditions of the weather and the time of day. In this they considered that the fine technical methods of Courbet could produce only spendid canvases painted in the studio. This resulted in the disintegration of light, in the study of the outdoors, of the play of iridescent color, of casual changes of light and shade, of all optical phenomena which make the atmosphere so changeable and so hard to represent. . . . This was the last stroke dealt classic and romantic painting. . . . This realistic movement begun by Courbet . . . has discovered truth in innumerable light effects.

Emile Zola, June 1879[1]

Artistic achievement is not measurable in isolation. The notion of an independent assessment of quality is by nature vague in the absence of a standard of comparison. Exhibitions offer valuable opportunities to examine firsthand a body of work drawn together for a specific purpose. If, however, we are to realize an exhibition's full potential, it is also necessary to view the selected works within an appropriate context. Childe Hassam (1859–1935) was an American Impressionist. His achievement as an artist rests within this tradition and within the broader context of the Impressionist era.

The foundations for the advanced modern styles of the late nineteenth and early twentieth centuries were laid by the work of the French Impressionists. The movement was by no means cohesive, and Impressionist theory was never systematized. Individual directions were as numerous as the participants in the eight Impressionist exhibitions that occurred between 1874 and 1886. The artists were, however, united in their revolutionary zeal and search for a modern means of expression.

In virtually all instances, Impressionism used a loose, painterly handling of pigment, a heightened palette and juxtaposed touches of color. Ceasing to imitate obvious illustrative appearances, the movement strove for an impression of reality, hence to retain a naturalism of a sort dictated by the artist's direct observation of the instantaneous effects of light. Impressionism sought to render the specific. It was after all an extension of Barbizon painting, and its potential was explored swiftly. Light replaced structure as a formal element and Impressionism withdrew from nature. Decorative color replaced functional color and the change resulted in the rejection of mass, the compression of depth, and the dissolution of form.

In this sense, the reality of the Impressionists was unquestionably subjective. It was evident that Impressionism had changed dramatically by the eighth and last group exhibition in 1886. The major artists concerned were already looking to the future by rejecting—or exploring further—this subjectivity. Vital considerations to our understanding of Impressionism are the brevity of the initial movement and the speed of its evolution. Impressionist color and light and the potential for abstraction that resulted from the subjective examination of reality were not the answer; rather, Impressionism was the essential link between the art of the early nineteenth century and that of the modern era.

In May 1888, six months after leaving Paris, Vincent van Gogh wrote to his brother Theo: "What I learned in Paris is leaving me and I am returning to the ideas I had . . . before I knew the Impressionists. . . . Because instead of trying to reproduce exactly what I have before my eyes, I use color more arbitrarily so as to express myself forcibly."[2] Although he rejected Impressionism as a method, he acknowledged its importance in a letter of 1890: "I believe in the possibility that a later generation will be, and will go on being, concerned with the interesting research on the subject of colors and the modern sentiment . . . and that Impressionism will be the source."[3]

The subjectivity of Paul Gauguin's response to Impressionism was expressed succinctly in his October 8, 1888, letter to fellow painter Emile Schuffenecker. He advised him: "Don't copy nature too closely. Art is an abstraction; as you dream amid nature extrapolate art from it and concentrate on what you will create as a result."[4] Maurice Denis emphasized the distinction between reality and a work of art in his 1890 *Définition du Néo-traditionnisme*, where he noted that a picture before anything else "is essentially a plain surface covered by colors arranged in a certain order."[5] Yet, Impressionism was not the source of the difference; it simply made it more apparent.

The introductory passage by Zola was drawn from his comments on the fourth Impressionist exhibition and appeared within his June 1879 review of Parisian artistic and literary news for the St. Petersburg publication *Viestnik Evrupi*. It is of interest for its clear description of the Impressionist style, limited perspective, and implication that Impressionism was a later stage in the development of Courbet's Realism.

Zola wrote from the limited perspective of the more cohesive early years of the Impressionist movement. He was understandably unaware of its future development and multiplicity of direction. As an author and critic, he was committed to Realism and saw Impressionism through Realism, not as a fundamental alteration in the way the artist perceived the visual world. The sense of rebellion and a continuing search for modern means of expression are absent.

Zola's lack of historical perspective is not an issue. The similarities between his description of Impressionism and the Impressionist movement in American art are important in a comparison of the American Impressionist aesthetic to its French source. A number of important events must first be considered.

In September 1883, the *International Exhibition for Art and Industry* opened in Boston. The Impressionist paintings furnished for its *Foreign Exhibition* by the Parisian dealer Durand-Ruel were largely a result of William Merrit Chase's awareness of Impressionism. On December 3, 1883, The *Pedestal Fund Loan Exhibition* opened in New York. It also included a number of Impressionist works. In 1886 Durand-Ruel shipped three hundred works to New York for the *National Academy of Design Special Exhibition: Works in Oil and Pastel by the Impressionists of Paris*, which opened on April 10 at the American Art Association Galleries. The entire exhibition was subsequently moved to the National Academy and opened there on May 25, 1886.

Durand-Ruel identified the romantic-realism of the Barbizon school as a foundation for Impressionism by including a number of Barbizon paintings in the 1886 exhibition. Impressionism's early direction and the limited historical overview these exhibitions provided gave greater weight to color and light as a means of revitalizing tradition. Largely ignored was Impressionism's radical break with the past and the resulting modernist direction that was already apparent in the Eighth Impressionist Exhibition of the same year.

America was receptive to foreign influence in the 1880s. The romanticism of the Hudson River School was tied to mid-nineteenth-century ideas and no longer appropriate to the rapidly developing nation. The realist tradition of the National Academy of Design dominated American painting. There was also a growing awareness that American artists and their institutions lagged behind their European counterparts. The inevitable desire to catch up caused many American artists to study abroad in the 1870s and 1880s. Although foreign ateliers and academies appeared advanced to these American students, with rare exceptions their studies fell within the tradition of academic realism. Although they did not participate in its developments, a small number of American artists traveled to Paris and took up the Impressionist method. Thus, when American artists sought to interpret for themselves the realist tradition with Impressionist color and light in the late 1880s, there remained clear distinctions between the American Impressionist aesthetic and its French sources.

American Impressionism retained a sense of control, a feeling for moderation and restraint in color and brush work. In contrast to the dissolution of form and local color common in its French counterpart, American Impressionism retained the integrity of local color and strove for a regularity of paint application and unfractured shape. American Impressionism rarely used flickering brush work to analyze light or form. Instead, it embellished surface and heightened the realistic appearance of its subject. The resultant reaffirmation of Realism paid little attention to the more abstract tendencies of the French Impressionists, and the evolution of American Impressionism was slow and confined within limited parameters.

The importance of a small group of American expatriot painters in making known these modern styles must also be recognized. James Abbott McNeill Whistler arrived in Paris in 1855, John Singer Sargent in the early 1870s. Though both owe much to Edouard Manet and should not be considered true Impressionist painters, their influence in America was significant. Mary Cassatt studied in Paris in the later 1860s and returned permanently in the early 1870s. She was invited to join the Impressionist group by Edgar Degas in 1877 and exhibited with the Impressionists in the fourth, fifth, sixth, and eighth exhibitions. The most significant American Impressionist painter, she was instrumental in introducing Impressionism to American collectors. In 1873 she met Louisine Elder, the future Mrs. H. O. Havemeyer, and her influence on the formation of the Havemeyer, Sears, and Potter Palmer collections cannot be over emphasized. In 1883 Claude Monet moved to Giverny, and before the end of the decade a number of American artists including Breck, Butler, Metcalf, Perry, Robinson, and Sargent took up residence there.

From Paris, Mary Cassatt wrote to J. Alden Weir on March 10, 1878: "I always have a hope that at some future time I shall see New York, the artist's ground. I think you will create an American school."[6] Her statement was prophetic. Between 1890 and 1900, Impressionism established itself as the predominant style in America. Frank W. Benson, Joseph DeCamp,

Thomas W. Dewing, Edmund C. Tarbell, Childe Hassam, Willard L. Metcalf, Robert Reid, E. E. Simmons, John H. Twachtman and J. Alden Weir joined together as The Ten American Painters in 1897. In founding the group Hassam and Weir hoped to call attention to American Impressionism through annual group exhibitions. The style Hassam was so instrumental in developing remained dominant into the 1920s.

Childe Hassam, christened Frederick Childe Hassam, was born in Dorchester, Massachusetts, on October 17, 1859. Like many of his contemporaries, his early training and first success as an artist were in illustration. During the later 1870s he furnished illustrations for such magazines as *Harper's, The Century, Scribner's* and *St. Nicholas.* His first designs for illustrated books appeared in 1883, and he continued to provide drawings and watercolors for books through the end of the 1890s. He returned to the graphic media in the second decade of the twentieth century, turning first to etching and drypoint in 1915 and then to lithography in 1917. He is, however, most often recognized for his accomplishments as a painter within the American Impressionist movement.

Hassam appears to have made a conscious decision to become an artist in 1878 and attended classes at the Boston Art Club that same year. He studied drawing at the Lowell Institute with William Rimmer and took painting lessons under Ignaz Marcel Gaugengigl. Hassam was related to William Morris Hunt, an American student of the Barbizon artist Jean-François Millet, and the collection of French paintings Hunt brought back to Boston was an important influence on the young artist.

Hassam was clearly a product of his era. His work from the early 1880s reflected current styles of American art: the realism of Winslow Homer and Thomas Eakins, the romanticism of the Hudson River School, the tonalism of George Inness, and the romantic-realism of the Barbizon school. In 1883, Hassam made the first of four trips to Europe. His chosen itinerary reinforced the academic nature of his early work.

His departure for Paris in the spring of 1886 was critical to his emergence as a leader of American Impressionism. His decision to further his studies abroad was an increasingly common one among young American artists. Hassam chose Paris for several reasons. He was acquainted with a group of artists who had studied in Paris, including Frank W. Benson, Emil Carlson, and Edmund C. Tarbell. He must also, as a result of the works already exhibited in America and the visibility of Impressionism in the American press, have been aware of the development in Paris of a new, modern style, and intentionally sought it out.

The pivotal year in his career was 1887. Before this date his work remained stylistically tied to the large tonalist compositions executed in Boston during 1885–86. *Une Averse, rue Bonaparte,* exhibited in the Salon of 1887, incorporated only minor Impressionist influences. *Le Jour du Grand Prix,* completed the same year, was clearly an experiment in Impressionism. Continued experimentation and a growing understanding of Impressionist technique can be traced in the remainder of his Paris compositions. He also remained essentially an American, and, typical of American Impressionism in general, he acknowledged within his work a respect for his subject.

Late in the summer of 1889, Hassam left Paris and after a brief stay in London settled in New York City. He established a pattern of painting in New England during the summer and working in his city studio during the winter. His paintings from the 1890s are among his finest achievements. They exhibit a rich and fluid application of paint, a clear understanding of Impressionist color and light, and a command of composition. Their subjects are commonplace

and, unlike the large-scale compositions of the 1880s, unpretentious in size and intent. He retained an American sensibility to what was represented.

He returned to Europe in the winter of 1896 and remained there through most of 1897. The journey reaffirmed his commitment to Impressionism. A significant consequence of this third European trip was a heightened sensitivity to light and color and more abbreviated brushwork. Less important during this period was Impressionist technique as a means of embellishing surface and heightening the realistic appearance of the subject. These more decorative compositions, resulting from a corresponding loss of clarity of form and compression of depth, were the nearest Hassam came to pure Impressionism.

Hassam's creative life lasted well into the twentieth century. He continued to use abbreviated brushwork and retained his interest in surface textures. He also brought to his later works an interest in his subjects that demanded a certain clarity in their representation. With rare exceptions, he remained distinctly an American Impressionist.

The founding of The Ten did not signify a rebellion against American conservatism. Its members were established artists, and their chosen style, an essentially conservative interpretation of Impressionism devoid of its more modernist sentiment, had long been acceptable. They were representative of a significant moment of confidence in American art. They made Impressionism a national style, and Childe Hassam should be considered one of its central figures.

The absence of Modernist content prevented American Impressionism from developing along the same lines as the European avant-garde. By their last group exhibition in 1919, The Ten had become an academy of American Impressionism. The future, this time made visible by the Armory show of 1913, was again a European invention, and the participants in the development of modern American painting had little in common with their American Impressionist contemporaries.

Their differences are immense. The modern sentiment was expressed by Marsden Hartley in his artist's statement written for the catalogue of the *Forum Exhibition of Modern American Painters* in 1916. He placed great emphasis on the need for individuality of expression and used Cézanne as an example when he wrote, "Who will not, or cannot, find that quality in those extraordinary and unexcelled watercolors of Cézanne, will find nothing whatsoever anywhere . . . they are expression itself. He has expressed, as he himself said . . . that which exists between him and his subject." In reference to his own work Hartley went on to say, "My personal wishes lie in the strictly pictorial notion. . . . Objects are incidents: an apple does not for long remain an apple if one has the concept."[7]

The suspicion and retrenchment of the American Impressionists toward modern trends was expressed by Childe Hassam when the question of modernism arose: "I don't know what anyone means by Modern Art. If Modern Art means the formless atrocities which are turned out by incompetents and sold under the guise of art by designing foreign dealers, then I have no use for it. Good art does not become old fashioned."[8]

Alain G. Joyaux

angularity of the figure are features easily traceable to early modernist influences. In *Diana's Pool, Appledore* the concern appears to be to depict the contrast between the soft flesh of the figure, the jagged rocks, and the foamy surf. Nevertheless, the patterning in the rocks and surf suggest that Hassam was well aware of other artistic styles. Although it may be impossible to ascertain the specific influences in these images, certain characteristics reminiscient of Fauvist and Post-Impressionist painting are evident. It has been suggested in the past that German Expressionism may also have influenced Hassam's prints; however, it is doubtful that he had much exposure to this type of work, since it received only limited attention in America before the 1920s. Perhaps the work of the Swedish artist Anders Zorn played a more important role in Hassam's prints. Zorn's etchings were exhibited at Frederick Keppel and Company of New York City in 1907 and 1913 and it is very possible that Hassam saw these exhibitions. Keppel was also a major dealer of Zorn's etchings in 1915 when Hassam exhibited seventy-five etchings and drypoints there. It is likely that he had the opportunity to see much of Zorn's etched work at this time. Zorn's prints show a distinctive use of line and pattern created through a rapid, bold working of the plate that in some instances is remarkably similar to that of Hassam. It is also evident that Hassam borrowed certain motifs from Zorn, particularly that of nudes bathing near the water's edge. Zorn was influenced by the Old Masters and greatly by various early modernist styles, including Impressionism and Post-Impressionism, and perhaps somewhat by German Expressionism. The appearance of these early modernist characteristics in Hassam's prints is probably a result of an awareness of these styles and an admiration of the prints of Zorn.

These traces of modern ideas in Hassam's etchings are not unusual. He visited Europe three times before the Armory show, and the majority of his etchings were done after 1914. However, it is known that he voiced antipathy toward modernism. It is also unusual that these modernist ideas are not as readily apparent in his paintings. Perhaps this indicates his willingness to experiment more with his new-found interest in printmaking than with his well-established reputation as an American Impressionist painter.

This sense of experimentation becomes clearer when viewing his entire output of prints. Hassam approached the plate in stylistically different ways, at times creating an image remarkable for its crispness and brevity and at others using bold, exuberant strokes to invoke a feeling of contrast or atmosphere. Throughout these varying styles, his decorative intentions remain apparent. He seems to prefer flatter imagery over a great sense of depth. Arrangements are scrutinized to the point of subordinating natural elements for the sake of formal composition. The various styles and techniques he used appear to be a means to these ends.

Hassam also experimented with lithography, although not to the same extent as his etchings. The same characteristics that appear in the etchings are often evident in the lithographs. The outstanding element that separates them is a greater degree of experimentation apparent in the lithographs. When looking at the body of his lithographs one finds very few completely Impressionist images. Most combine traits associated with both the Impressionist and Expressionist styles. Some prints even appear strikingly modern and lean toward abstraction. *The French Cruiser* (cat. no. 58, p. 60), with its generalized background and planar representation, shows little concern for the effects of light and shadow and deals primarily with composition and the exploration of the tusche technique of lithography. The image remains basically Im-

pressionistic and reminiscent of the lithotints of Whistler in its handling, but we see a much broader generalization of the subject.

The methods used to create the lithographic and etched images vary as widely as the stylistic tendencies within them. Hassam adhered to no set formula while working. Sometimes he preferred to work out of doors directly on the plate and other times worked in his studio from quick notations taken earlier. Many of the prints were from a direct transfer of a drawing onto the plate and stone. Others were made from drawings that predate his serious efforts at print-making. Many of the etched plates, the earliest ones in particular, were reworked and finally completed many years later. He also used a variety of paper, both of European and American origin. A few of the etchings are on various antique papers including ledger and Bible paper.

Hassam published all of his printmaking attempts. Even his earliest efforts are well documented, providing a clear survey of his different approaches to the medium. He produced no fewer than 421 plates during his lifetime, 376 etchings and drypoints and 45 lithographs. Of these, 61 prints exist today in Indiana public collections. Twenty-six are lithographs of 19 different images; 36 are etchings and drypoints representing 34 separate images. All of the lithographs were printed by George C. Miller of New York City from plates and stones worked by Hassam during 1917–18. Most of the etchings were printed by Hassam himself between 1915 and his death in 1935.

The two largest groups of the Indiana Prints were donated to their respective institutions by Mrs. Childe Hassam in 1940 through the Kleeman Galleries of New York City. This depth of Hassam's representation in Indiana collections is a direct result of the limited market for his prints. They experienced negligible sales between 1920 and 1934, prompting Mrs. Hassam to distribute them to public institutions throughout the country. The lack of sales for Hassam's printed work strikes an ironic note. The prints were much heralded for their imagery and technical qualities. He had won numerous awards for his etchings and had also participated in many exhibitions. Perhaps the prints' commercial failure can be attributed to a general decline of public interest in the graphic media at this time. Nevertheless, we can be grateful for Mrs. Hassam's generosity, without which this exhibition would be limited.

Brian A. Moore

Muncie Collects Its First Childe Hassam

The Muncie art movement began to develop late in the nineteenth century. J. Ottis Adams was the first to organize a group of people interested in art when he began offering painting classes in 1888. He was joined by William Forsyth, and in 1889 the two founded the Muncie Art School. When the school closed in 1891, a void was created in the art environment of Muncie. His students, all women, banded together the next year to organize the Art Students' League. This ladies' club, with a restricted membership, soon promoted the concept that an organization with a larger membership base was also needed. Thus in 1906 the Muncie Art Association was formed.

The Art Students' League and the Art Association were aware of the art movements that were developing throughout the state—for example, the Art Association of Richmond and the Hoosier Salon, begun in the middle 1920s. The Art Association of Indianapolis and The John Herron Art Institute were always looked to with admiration and interest. The Muncie Art Association and the Art Students' League followed the activities of the Art Institute and took advantage of their resources by sponsoring field trips to the institute and bringing speakers from its staff to Muncie.

Muncie was a community well endowed with enlightened civic leaders who realized that art was essential to the cultural environment. The earliest known discussion promoting the idea of a permanent art gallery for Muncie was recorded in the minutes of the association in 1907. The association, however, was unable to accomplish its dream, and another twenty-eight years elapsed before Ball State Teachers College and the Ball family combined resources to make the gallery a reality in 1935.

It is fitting that in this year, the fiftieth anniversary of the Ball State University Art Gallery, Alain Joyaux has chosen to feature an exhibition of Childe Hassam. In 1907, a Hassam painting became the pride of the Muncie Art Association's collection. This acquisition served as an example of community connoisseurship around which a tradition of art patronage developed. This tradition led to the creation of much of the collection currently enjoyed in the gallery.

The Muncie Art Association was organized in 1906 with the stated objective of sponsoring exhibitions and of "purchas[ing] one of these pictures each year, as a beginning of a permanent collection . . . to be located in some public building accessible to all members at any time, for study." This was the first effort made by the citizens of Muncie to have a public permanent collection of paintings for the enjoyment of the community. The association financed its projects with fifty-cent membership fees and occasional donations from members. Most important, it relied on the dedicated energy of its membership to promote art aggressively in the city.

In the beginning, the association sponsored an exhibition each spring with the intention of purchasing a painting for its collection. After the first exhibit in 1906, with the cooperation of the Art Students' League, the association purchased *The Sand Pit* by Carl Wiggins, a student

of George Inness and an artist of modest reputation at the time. Mounting the exhibit of 1906 was a task almost beyond the ability and resources of a neophyte organization. The assistance of a more experienced organization was needed if they were to continue with effective exhibits.

At the time, Richmond, Indiana, had a more mature and experienced art association (founded in 1898) that was organizing its own exhibits. One of the charter members was Ella Bond Johnston, who became president in the organization's second year and served for the next seventeen years. The purpose of this association was to promote artists and the appreciation of art in the community. However, through the vision and creative leadership of Mrs. Johnston, the Richmond Art Association would contribute substantially to the exhibition of art in Indiana and receive national acclaim. Through much effort the association was able to establish a permanent art gallery as part of the Richmond High School so that art might be an integral part of the educational environment of students and at the same time be available to the adults of the community.

To accomplish this objective, the Art Association of Richmond held annual exhibitions that included the work of many prominent artists from Indiana as well as from the east. The expense of such important exhibitions was rather high for a local art association to bear alone. During the Richmond exhibit of 1907, Mrs. Johnston wrote that "when a number of paintings were shown by New York painters, it became apparent that our association could not meet every year the $600 expense for such a fine exhibit." The Muncie Art Association was invited to participate and agreed to pay a share of the expenses.

The Muncie Art Association had now established a working relationship with its counterpart in Richmond. In fact, the relationship proved to be so successful that the Richmond association expanded the showing of its exhibits to cities such as Fort Wayne, Lafayette, Terre Haute, Vincennes, and Indianapolis. Johnston was ecstatic and reported, "An art revival was started and there was preaching and praying, exhorting and singing around the State in true evangelical spirit."

The spring exhibit of 1907 had among its paintings a Childe Hassam, *Entrance to the Sirens' Grotto, Isles of Shoals* (see catalog no. 5, p. 32). The infant Muncie Art Association, already in financial difficulty, coveted the Hassam. To complicate matters, the asking price for the painting exceeded the association's self-imposed $100 limit. At an association meeting, Mrs. Frank C. Ball reported that Mr. Hassam had wired that he would discount his painting to $400—still $300 over the limit. Mr. Frank C. Ball and Mr. George McCulloch organized a subscription drive, seventeen persons contributed from $10 to $40 each for a total of $570, and the association became the proud owner of a Childe Hassam.

In the following years the association continued its working relationship with the Richmond Art Association and made purchases as often as financial conditions permitted. The collection grew to include works by J. Ottis Adams, Palmer, Bessire, Breverman, and Francis F. Brown—to name a few from a 1960 inventory list of twenty-two.

In 1914, the Muncie Art Association received a serious blow. The Commercial Club informed them that the exhibition space they had been using was needed for other purposes and would hence no longer be available. As a result of this setback, the exhibitions were discontinued, and the collection was moved to the Muncie Public Library. In 1922, Flora Bilby, chairman of the Central High School art department, urged the association to sponsor several

small exhibits in the hallway of the high school throughout the year. It was at this time that the association decided to move its permanent collection from the Muncie Library to Central High School on permanent loan.

The financial condition of the association worsened, and a year later it went inactive for a period of five years, leaving the collection, including the Hassam, hanging in the hallway of the school. In 1925 the Muncie Art Students' League assumed responsibility for the paintings, moving them back to the Muncie Library for safekeeping and exhibition. In 1928, the Muncie Art Association was reactivated and again began organizing art exhibits in the new exhibition area in the Ball State Teachers College Library, completed in 1927.

In the 1960s, however, the association again found itself in financial difficulty. To meet expenses, it looked to the collection as a possible source of revenue. The paintings were offered to the community for rental and were distributed throughout the city to various homes and offices for modest fees. The odyssey of the Hassam carried it from one place to another. In spite of the rental program, the association's financial problems continued, and once again it looked to the collection as a source of possible income. The membership was unaware that, during the time the collection had been in the possession of the association, it had increased in value and was not even insured. When an appraisal revealed the change in value, they were surprised to find that the Hassam in particular had become quite valuable. It was immediately recalled from rental and appropriately insured.

This news made it appear that a simple solution to the association's financial problems was at hand—sell the Hassam. Much debate ensued over the financial necessity of the sale as opposed to the significance of the painting in the tradition of the association and of Muncie itself. It was ultimately decided that the Hassam should not be sold but instead be given to the Ball State Gallery for its permanent collection. This gift was an important and appreciated acquisition. But the Muncie Art Association's financial problems remained unsolved; in the 1970s the association ceased to exist, and the remainder of the collection was presented to the gallery.

Childe Hassam was the first significant artist collected by the community of Muncie. The citizens immediately recognized the merit of this artist and took pride in the fact that *Entrance to the Sirens' Grotto, Isles of Shoals*, was part of their collection. It became a symbol of sacrifice and dedication by early art patrons who were striving to bring to Muncie quality art for the whole community to enjoy. The Hassam, as well as the other paintings collected by the association, created a spirit of patronage that continued to grow and set the example for others to follow in the future.

The Ball State University Art Gallery has been the beneficiary of this philanthropic tradition that has enriched the citizens of Muncie and east central Indiana. It is for these reasons that the Childe Hassam exhibition on the fiftieth anniversary of the Art Gallery carries such significance. The art tradition in Muncie has grown and become an example for others to follow. If the citizens of Muncie and the patrons of the Ball State University Art Gallery exercise the same interest, patronage, and devotion during the next fifty years, the centennial celebration in the year 2035–36 will be an event well worth anticipating.

Ned H. Griner

Art Exhibitions in Paris 1886–1889

This list of exhibitions is included to provide the reader with an overview of the most important exhibitions that were available to Hassam during his stylistically critical second European trip. Although it is not possible to ascertain whether he attended these exhibitions, their accessibility and the dramatic change that took place in his work between 1886 and 1889 indicate a growing awareness of many of the artists represented.

The information is drawn from many sources, including reviews and publications from the period. Important contemporary sources include Welch-Ovcharov, Bogomila. *Vincent Van Gogh: His Paris Period, 1886–1888*, Utrecht-Den Haag: Editions Victorine, 1976; Rewald, John. *The History of Impressionism*, New York: The Museum of Modern Art, 1973; and Rewald, John. *Post Impressionism: From Van Gogh to Gauguin*, New York: The Museum of Modern Art, 1978.

Notes on the artists included are provided only to indicate potential sources of inspiration, not accurate accounts of the exhibitions.

AGJ

1886	March 27–?	*L'Exposition des aquarelles de Gustave Moreau* Galerie Bernheim Jeune 8 rue Laffitte
	April 1	Musée du Luxembourg (reopened after renovation)
	April 3–30	*II^e Exposition de la Société de Pastellistes Français* Galerie Georges Petit 8 rue Sèze
	April 15–May	*L'Exposition des maîtres du siècle* 3 rue Bayard (included: Corot, Delacroix, Millet)
	May 11–29	*Salon des refusés* 16 rue Laffitte
	May 15–June 15	*VIII^e Exposition de peinture impressioniste* 1 rue Laffitte (included: Cassatt, Degas, Gauguin, Guillaumin, Morisot, Pissaro, Redon, Seurat, Signac)
	June–July 15	*V^e Exposition internationale de peinture* Galerie Georges Petit 8 rue Sèze (included: Monet, Renoir)
	August 21–September 21	*II^e Exposition de la Société des Artistes Indépendants* Baraquement des Tuileries (included: Cross, Pissaro, Seurat, Signac, van Gogh)

1886–87 December–January — Galerie Martinet (included: Pissaro, Seurat, Signac)

December–January — *Whistler* / Galerie Georges Petit / 8 rue Sèze

1887 March 26–May 3 — *IIIᵉ Exposition de la Société des Artistes Indépendants* / Pavillon de la Ville de Paris / (included: Cross, Pissaro, Redon, Seurat, Signac)

May 1–June 20 — *L'Exposition des oeuvres de Jean-François Millet* / École des Beaux-Arts

May 8–June 8 — *VIᵉ Exposition internationale de peinture et de sculpture* / Galerie Georges Petit / 8 rue Sèze / (included: Monet, Pissaro, Renoir, Sisley)

November 19–December 20 — Grand-Bovillon Restaurant de Chalet / 43 avenue de Clichy / (included: Toulouse-Lautrec, van Gogh)

December — Galerie Boussod et Valadon / 19 Boulevard Montmartre / (included: Gauguin, Pissaro)

1887–88 December–January — *Exposition des 33* / Galerie Georges Petit / 8 rue Sèze

1888 January 23–February 15 — *Edgar Degas* / Galerie Durand-Ruel / 16 rue Laffitte

March 22–May 3 — *IVᵉ Exposition de la Société des Artistes Indépendants* / (included: Anguetin, Cross, Seurat, Signac, van Gogh)

May 25–June 25 — *Divers artistes* / Galerie Durand-Ruel / 16 rue Laffitte

June — *Monet* / Galerie Boussod et Valadon / 19 Boulevard Montmartre

November — *Gauguin* / Galerie Boussod et Valadon / 19 Boulevard Montmartre

1889 January–February — *Exposition des peintres-graveurs* / Galerie Durand-Ruel / 16 rue Laffitte

March — *L'Exposition de peintures du groupe impressioniste et synthétiste* / Café Volpini / Champ-de-Mars

Spring — *Exposition universelle beaux-arts: centennale de l'art français 1789–1889*

Monet et Rodin / Galerie Georges Petit / 8 rue Sèze

Monet / Galerie Boussod et Valadon / 19 Boulevard Montmartre

September 3–October 3 — *Vᵉ Exposition de la Société des Artistes Indépendants* / (included: Anguetin, Cross, Seurat, Signac, Toulouse-Lautrec, van Gogh)

Chronology

Residences, Studios, Travel 1880–1935

1880		Dorchester, Massachusetts (family home)
1882		Gloucester, Massachusetts
1883	spring	Europe (Glasgow, Edinburgh, London, Dunkerque, Brittany, Switzerland ?, Venice, Naples, Florence, Granada) 149 Tremont Street, Boston
1886– 89	spring	11 Boulevard Clichy, Paris (Villiers-le-Bel, France)
1889	summer	Boulevard Rochechouart, Paris
	summer– October	London 95 5th Avenue, New York, New York
1890	summer	Appledore, Isles of Shoals, Maine
1892		Chelsea Hotel, West 23rd Street, New York, New York
1893		The Rembrandt, 152 West 57th Street, New York, New York
1894	summer	Appledore, Isles of Shoals, Maine
1895	January	Havana, Cuba
1896	(winter)– 1897	Europe (London, Paris, Pont-Aven, Naples, Rome, Florence)
1898	summer	Appledore, Isles of Shoals, Maine
1899	summer	Gloucester, Massachusetts Appledore, Isles of Shoals, Maine
1900	summer	Provincetown, Massachusetts
1901		The Rembrandt, 152 West 57th Street, New York, New York 139 West 55th Street, New York, New York
	summer	Newport, Rhode Island Appledore, Isles of Shoals, Maine
1902		139 West 55th Street, New York, New York
1903	July August	Old Lyme, Connecticut Appledore, Isles of Shoals, Maine
1904	summer	Old Lyme, Connecticut
1905	summer	Old Lyme, Connecticut
1906		27 West 67th Street, New York, New York
	summer	Old Lyme, Connecticut Appledore, Isles of Shoals, Maine
1907	summer	Old Lyme, Connecticut
1908		27 West 67th Street, New York, New York 130 West 57th Street, New York, New York San Fransisco, Portland, and Harney Desert, Oregon

1909	summer	East Hampton, Long Island Appledore, Isles of Shoals, Maine	1917	summer	East Hampton, Long Island
1910		Europe (Paris, Grèz, Toledo, Ronda)	1918	summer	East Hampton, Long Island Gloucester, Massachusetts
1911	summer	Appledore, Isles of Shoals, Maine	1920	summer	East Hampton, Long Island (permanent summer address)
1914		San Francisco, Carmel	1927		Los Angeles
1915	summer	Cos Cob, Connecticut	1934	October	East Hampton, Long Island
			1935	August 27	died East Hampton, Long Island

Catalogue of Paintings, Drawings, and Watercolors

Title: Additional titles the work has been known by, or published as, appear within parentheses.

Medium and Support: Unless noted otherwise, oils on canvas are stretched.

Dimensions: Height precedes width.

Inscriptions: Unless noted otherwise, there is no reason to believe that they are by the artist. The use of a virgule indicates a second line within the same inscription. Labels indicative of current ownership are not listed unless they include pertinent information.

Provenance: All tranfers of ownership are direct except where the semicolon is followed by a question mark.

References: Unpublished manuscript materials are listed separately following published references.

AGJ

1. *Montmartre* 1889
oil on canvas (solid wood insert, verso, stretcher)
39.5 × 44.2 cm, 15½ × 17⅛ inches
signed in brown oil paint, lower left: *Childe Hassam.*
 Paris. 1889
and in vermillion oil paint, verso, wood insert, center:
 ⓒⒽ *1889*
inscribed in black pen, verso, stretcher, upper right:
 28
and in pencil, verso, stretcher, upper right: *Place du*
 Tertre
bears E. & A. Milch, Inc., label, verso, frame, upper
 right

Ball State University Art Gallery
Permanent loan from the Elisabeth Ball Collection,
 George and Frances Ball Foundation
L83.026.10

In the spring of 1886, Hassam vacated his Boston
studio and departed again for Europe. He rented an
apartment and studio at 11 Boulevard Clichy, Mont-
martre, and except for an occasional journey to
Villiers-le-Bel, made no effort to travel. The three years
Hassam spent in Paris were critical to his maturity as an
artist. There he witnessed firsthand the continued ex-
periments of the Impressionists and swiftly incor-
porated their ideas into his work.

In his first major Paris work, *Une Averse, Rue
Bonaparte* (1887, oil on canvas, 40¼ × 77¼ inches,
private collection), he combines the grayed tonalist
palette typical of his early work with freer brushwork
and hints of Impressionistic color. Indeed the success
the painting achieved in the Salon of 1887 was un-
doubtedly the result of this less than adventurous
assimilation of an aesthetic that was then still con-
sidered avant-garde.

Montmartre depicts the Place du Tertre from the
south, a scene approximately three blocks from
Hassam's studio. Here he exhibits a clear, though
perhaps conservative, command of the Impressionist
aesthetic and experiments with a composition
dramatized by a foreground shadow, a middleground
bathed in the full light of day, and a clear blue sky.

CONDITION:
Excellent
paste lined to canvas support

PROVENANCE:
Childe Hassam; ? ; E. & A. Milch, Inc., New York,
New York, before April 1924; Mr. and Mrs. George A.
Ball, Muncie, Indiana, April 12, 1924; Miss Elisabeth
Ball, Muncie, Indiana, before 1957; George and
Frances Ball Foundation, Muncie, Indiana, April 29,
1982.

EXHIBITIONS:
Muncie, Ball State University Art Gallery, on loan,
July 22, 1983—; Muncie, Ball State University Art
Gallery, *The Elisabeth Ball Collection of Paintings, Draw-
ings, and Watercolors: The George and Frances Ball Foun-
dation*, January 15–February 26, 1984, cat. no. 10, il-
lustrated p. 19.

REFERENCES:
Joyaux, Alain. *The Elisabeth Ball Collection of Paintings,
Drawings, and Watercolors: The George and Frances Ball
Foundation*, Muncie; Ball State University Art Gallery,
1984, p. 19.
 Unpublished: Invoice dated April 12, 1924, #6692, E.
& A. Milch, Inc.

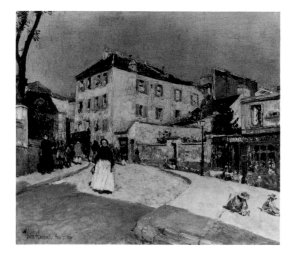

see color plate I, p. 34

2. *Under the Lilacs* undated, circa 1889
oil on panel (Rey & Perro, Paris)
31 × 41 cm, 12⅛ × 16 inches (#6 paysage)
signed in black ink ? , lower left: *CHILDE HASSAM*
and in black ink, verso, upper center: *Under the Lilacs
 / Childe Hassam / 95 5th Ave. N. Y.*
inscribed in black crayon, verso, upper right: *3*
and in black crayon, verso, lower left: *225*
and in pencil, verso, upper left: *1274-16*
and in pencil, verso, lower right: *97*
stamped in red ink, verso, upper right: *3973 ?*
and in red ink, verso, center left: *6*
bears in black ink on red bordered white paper tag,
 verso, lower center: *1/18/4*

The Snite Museum of Art, University of Notre Dame
Gift of Mr. and Mrs. Terrance Dillon
76.55.1

Although undated, *Under the Lilacs* can be assigned on both technical and stylistic grounds to the later stages of Hassam's Paris period. The painting is executed on a standard-sized (#6 landscape) wooden panel purchased from Rey and Perro, 51 Rue Rochechouart, Paris, and bears Hassam's later New York address, indicative of its subsequent transport with the bulk of the Paris works in the autumn of 1889.

Hassam's occasional journeys to Villiers-le-Bel, thirteen kilometers north of Paris, were important to his increased use of Impressionistic color and the pictorial effects of light. Here he embraced nature, the brightly colored gardens and light filtered by foliage. Each

experience encouraged further experimentation in Impressionism, and it is thus tempting to place the execution of this work in Villiers-le-Bel rather than Paris.

The painting is related to a much larger work entitled *Mrs. Hassam in Their Garden* (1889, 34 × 52½ inches, private collection) and typical of both is the artist's romantic interpretation of the scene. The broken brushwork and color harmony look forward to such works as *The Old Lyme Bridge* and *Rock Cliff, Appledore* (cat. nos. 6 and 7 respectively).

CONDITION:
Excellent

PROVENANCE:
Childe Hassam; ? , February 7, 1896; ? ; Mr. and Mrs. Terrance Dillon, Winnetka, Illinois, circa 1960; The Snite Museum of Art, University of Notre Dame, Notre Dame, Indiana, 1976.

EXHIBITIONS:
Notre Dame, The Snite Museum of Art, University of Notre Dame, *A Decade of Collecting: 1970–1980*, introduction by Stephen B. Spiro, catalogue by Susan P. Bastian, September 23–December 31, 1979, cat. no. 74, illustrated p. 53.

REFERENCES:
American Art Galleries, American Art Association, *Catalogue of the Oil Paintings, Watercolors and Pastels by Childe Hassam*, New York: American Art Galleries, American Art Association, 1896, sale, February 6–7, 1896, lot. no. 180.

see color plate II, p. 35

29

3. *untitled* undated, circa 1888–1895
oil on pressed paper board
9.7 × 14.7 cm, 4 × 5¾ inches
signed in pencil on brown paper adhered to verso,
 upper right: *Childe Hassam*

Evansville Museum of Arts and Science
William P. Gumberts bequest
84.30.188

The absence of a date and recorded title and its extremely small scale and abbreviated subject make it necessary to rely solely on stylistic grounds in order to place this oil sketch within Hassam's oeuvre. The broken, assured brushwork is clearly Impressionistic and must post-date his acceptance of the Impressionistic aesthetic in 1887–88. The paint surface retains a sense of fluidity common to his paintings from the early 1890s. The color is rich and although Impressionism is clearly its source, there is little hint of the revolution in light that occurs in works dating from the mid- to late 1890s.

It is doubtful that the sketch was intended as a preparatory study for a finished work. Rather, it was a means to work out ideas, to respond to a particular source of inspiration, and to experiment informally with the possibilities of the new style. This experimentation led to the rejection of his early interests in tonalism and his emergence as a mature Impressionist artist in the later 1890s.

Exhibited in Muncie only

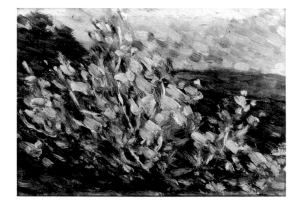

4. *Regent Circus, London* undated, 1897
(Picadilly Circus, London)
pencil, black with blue heightened with yellow, green, and red on off-white paper
29.1 × 21.6 cm, 11½ × 8½ inches
signed in black pencil, lower left: *C. H.*
inscribed in black pencil, lower left: *To W. H. / with affection*

Indianapolis Museum of Art
Gift of Mrs. Wood L. Wilson
48.83

In 1876, Hassam was accepted as an apprentice by the Boston wood engraver George E. Johnston. He quickly mastered the techniques of the craft while continuing to pursue his interest and talent in drawing. Although Hassam did not begin formal drawing classes until 1878, he was sufficiently proficient to find success as a free-lance illustrator shortly after 1876 and continued to furnish images for a variety of publications through the turn of the century.

In 1894, Hassam provided the illustrations for Celia Laighton Thaxter's collection of poems *An Island Garden*. The title was a reference to her idyllic Appledore garden, which replaced Villiers-le-Bel as a source of inspiration in the summer of 1890. Drawings of London and Paris, executed during his third European journey, extending from the winter of 1896 through late 1897, and drawings executed in New York appeared in the 1899 publication *Three Cities by Childe Hassam*. His work from this era is distinguished by a thorough assimilation of French Impressionism and can be compared with contemporary work by Pissaro and Sisley. Subsequent to its publication in *Three Cities*, Hassam gave the drawing to his friend and fellow illustrator Walter Hale (1869–1917), thus accounting for its present inscription: *To W. H. with affection.*

CONDITION:
Good
backed with Japanese tissue, minor restorations

PROVENANCE:
Childe Hassam; Walter Hale, New York, New York after 1899; Louise Closer Hale (wife), December 4, 1917; ? , circa 1933; Mrs. Wood L. Wilson, New York, New York; The John Herron Art Institute (Indianapolis Museum of Art), September 11, 1948.

REFERENCES:
Russell, R. H. *Three Cities by Childe Hassam,* illustrated by Childe Hassam. New York: R. H. Russell, 1899, unpaginated, illustrated.

Unpublished: Letter dated May 13, 1980, Kathleen M. Burnside, research associate, Hirschl and Adler Galleries, New York, New York, to Martin F. Kraus Jr., assistant curator of prints and drawings, Indianapolis Museum of Art.

5. *Entrance to the Siren's Grotto, Isles of Shoals* 1902
 (summer)
(*Grotto-Entrance to the Isle of Shoals; Entrance to the
 Grotto—The Island of Shoals*)
oil on canvas
46 × 56.2 cm, 18 × 22 inches
signed in red oil paint, lower right: *Childe Hassam /
 1902*

Ball State University Art Gallery
Gift of the Muncie Art Association
71.10

The works executed during Hassam's summer visits to
the Isles of Shoals, a group of nine islands ten miles off
the coast in the vicinity of Portsmouth, New Hamp-
shire, and Kittery, Maine, are perhaps some of the most
powerful of his career.

In 1838, Thomas Laighton, keeper of the lighthouse
on White Island, purchased Hog Island and renamed it

Appledore, after an eighteenth century Devon fishing
village. Laighton and Levi Thaxter opened Appledore
House as a summer resort hotel ten years later.
Laighton's daughter Celia, poet, prose writer and en-
thusiastic gardener, married Thaxter in 1852, played an
important role in the development of the resort, and
assured its importance as a summer gathering place for
authors and literary figures.

Hassam knew Celia Thaxter as a pupil in his Boston
watercolor classes during the early 1880s and, although
he may have first visited Appledore at that time, his
earliest Appledore subjects appear about 1890. Celia's
garden was the subject of the oil painting and eleven
watercolors reproduced as illustrations in *An Island
Garden*. Although Celia died in 1894, the wild, unkept
grounds of Appledore House and the powerful Isles of
Shoals landscape remained an important motif through
the summer of 1916.

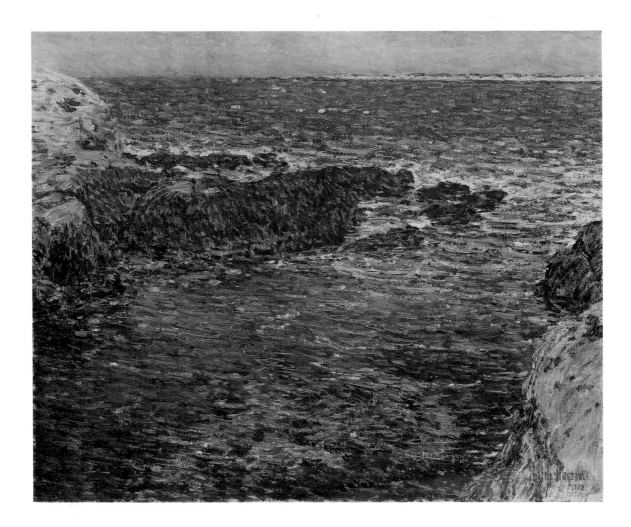

As is typical of the Isles of Shoals landscapes, Hassam's use of a high horizon in *Entrance to the Siren's Grotto, Isles of Shoals* emphasizes the brutal relationship of the sea and rocks. Unlike his French sources, his mature Impressionist style gives little attention to varying qualities of light and light as a means of dissolving one form into another.

CONDITION:
Excellent

PROVENANCE:
Childe Hassam; Muncie Art Association, Muncie, Indiana, May 29, 1907; Muncie Art Students' League, Muncie, Indiana, March 2, 1925 (as custodian for inactive Muncie Art Association); Muncie Art Association, September 1928; Ball State University Art Gallery, Muncie, Indiana, June 23, 1971.

EXHIBITIONS:
Muncie, Muncie Art Association, *Second Annual Exhibition of the Muncie Art Association,* May 16–27, 1907, cat. no. 35; Richmond, Art Association of Richmond, *Eleventh Annual Exhibition of the Art Association of Richmond, Indiana, Garfield School Building,* June 11–25, 1907, cat. no. 35; Muncie, Muncie Public Library, on loan, 1907–1922; Pittsburgh, Department of Fine Arts, Carnegie Institute, *Fourteenth Annual Exhibition,* May 2–June 13, 1910, cat. no. 133; Muncie, Central High School, on loan, 1922–circa 1925; Muncie, Muncie Public Library, on loan, circa 1925–1928; Muncie, Ball State Teachers College, Library Art Gallery, on loan, circa 1928–?.

REFERENCES:
Ball State Teachers College. "Catalogue of Paintings, Sculpture and Other Art Objects at Ball State Teachers College, Muncie, Indiana," *Ball State Teachers College Bulletin,* vol. XXIII, no. 1, September 1947, p. 14, as *Grotto-Entrance to the Isle of Shoals*; Griner, Ned. *Side by side with Coarser Plants: The Muncie Art Movement, 1885–1985.* Muncie: Ball State University, 1985, p. 43.

Unpublished: Minutes dated May 29, 1907, Muncie Art Association, Muncie, Indiana; Letter dated March 10, 1981, Kathleen M. Burnside, research associate, Hirschl and Adler Galleries, New York, New York, to Dolores Terhune, assistant to the director, Ball State University Art Gallery.

6. *The Old Lyme Bridge* 1903 (July)
(*Lyme Bridge; The Old Bridge; Bridge at Old Lyme; Bridge at Lyme; The Bridge at Lyme*)
oil on canvas
61.8 × 66.4 cm, 24¼ × 26 inches
signed in black oil paint, lower left: *Childe Hassam 1903*
and in red oil paint, verso, center: ⒸⒽ *1903*
bears William Macbeth, Inc., label, verso, frame, upper center and William Macbeth, Inc., inventory stamp, verso, stretcher, upper right: *3759*
and William Macbeth, Inc., inventory stamp, verso, frame, upper right: *8248*

Ball State University Art Gallery
Gift of the E. B. Ball heirs
80.010.6

The open meadows, the woods, and the Duck, Black Hall, Lieutenant and Connecticut rivers wandering through the salt marshes to Long Island Sound made Old Lyme, Connecticut an ideal rural setting for artists seeking an alternative to the summer heat of Boston and New York City. Henry Ward Ranger arrived in Old Lyme in the summer of 1899 and was soon presiding over a growing number of tonalists. Contemporary references to Old Lyme as "the American Barbizon" were common.

The artists rented rooms at Holy House, Florence Griswald's late Georgian mansion on Lyme Street, and used a number of small buildings on the grounds as studios. Today, Holy House remains open to the public as the Florence Griswald Museum and is home to the Lyme Historical Society. Nonetheless, Willard Metcalf's 1906 painting of its temple-like façade guarded by

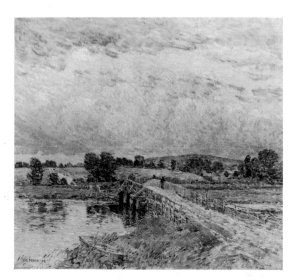

see color plate III, p. 38

33

Plate I, *Montmartre*, catalogue no. 1, p. 28

Plate II, *Under the Lilacs*, catalogue no. 2, p. 29

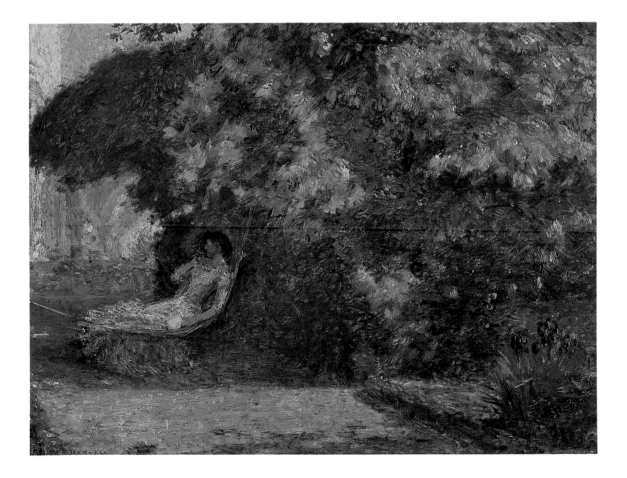

Plate III, *Old Lyme Bridge*, catalogue no. 6, p. 33

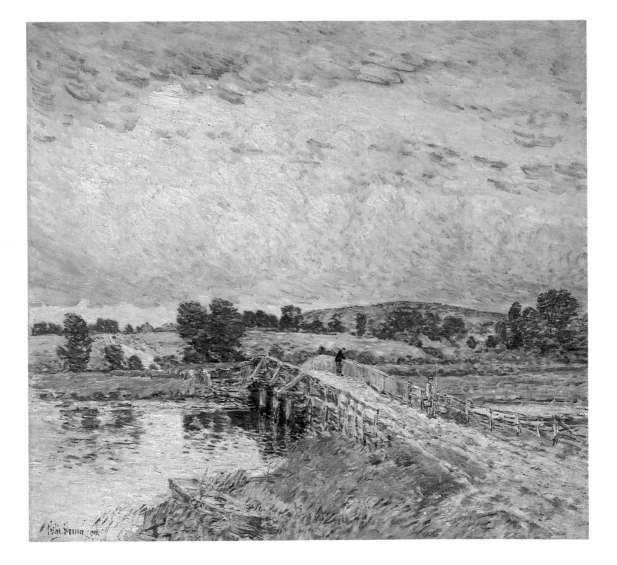

Plate IV, *Bowl of Goldfish*, catalogue no. 8, p. 40

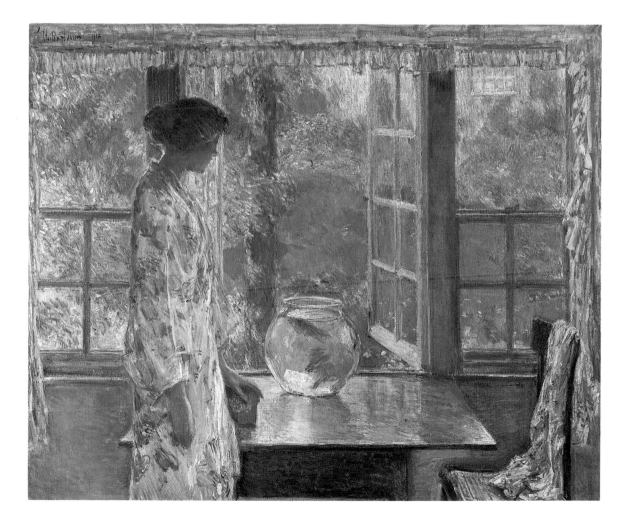

8. *Bowl of Goldfish* 1912
oil on canvas
64.2 × 77.1 cm, 25⅛ × 30¼ inches
signed in brown oil paint, upper left: *Childe Hassam
 1912*
and in red oil paint, verso, center: ⓒⒽ *1912*
bears William Macbeth, Inc., label, verso, frame,
 upper center
and William Macbeth, Inc., inventory stamp, verso,
 stretcher, upper member: *8423*
and William Macbeth, Inc., inventory stamp, verso,
 frame, upper center: *1757*
and Grand Central Art Galleries, label, verso, frame,
 upper member, inscribed: *#A 3672*

Ball State University Art Gallery
Permanent loan from the Frank C. Ball Collection,
 Ball Brothers Foundation
L37.142

In the summer of 1910, Hassam made his last trip to
Europe and, although he was clearly a mature artist
before his departure, selected works after this date ex-
hibit a bold and more decorative use of color. Specific
influences are difficult to identify, yet it is clear that he
was not ignorant of the later work of the French Im-
pressionists and their American followers as well as the
color experiments of the Post Impressionists.

About the same time, Hassam returned to the theme
of the female figure. In a group of related compositions
executed over the next decade and subsequently la-
beled the New York Window Series, he consistently
used a backlighted window and unified tone to
establish mood. His interpretation of the subject is
clearly romantic and, although closely related to con-
temporary themes in American painting and literature,
must also be compared to the romantic sensibility of
Under the Lilacs (cat. no. 2, p. 29) and other garden
scenes from 1888–89.

Bowl of Goldfish was the first of two strikingly similar
compositions. *The Goldfish Window*, a mirror image of
the first version, was executed in 1916 (oil on canvas,
30¼ × 50 inches, The Currier Gallery of Art, Man-
chester, New Hampshire). In both works, Hassam un-
doubtedly portrayed his wife Maude, née Kathleen
Maude Doane, against the window of their residence at
130 West 57th Street. The view seen through the win-
dow remains the source of color and light, and Hassam
uses the goldfish bowl as a focal point to soften the con-
trast between interior and exterior.

CONDITION:
Excellent

PROVENANCE:
Childe Hassam; Charles V. Wheeler, circa 1913;
William Macbeth, Inc., New York, New York,
November 2, 1935 (consigned to; ? , January 3, 1936;
Currier Gallery of Art, Manchester, New Hampshire,
December 31, 1936; Grand Central Art Galleries, New
York, New York, February 13, 1937); Frank C. Ball,
Muncie, Indiana, March 10, 1937; Ball Brothers Foun-
dation, Muncie, Indiana, circa 1937.

EXHIBITIONS:
Washington D. C., The Corcoran Gallery of Art,
*Fourth Exhibition of Oil Paintings by Contemporary
American Artists*, December 17, 1912–January 26, 1913,
cat. no. 136; Muncie, Muncie Art Association, Ball
State Teachers College, *Exhibition of Paintings and
Sculpture by Leading American Artists, from the Grand
Central Galleries, Inc.*, March, 1937, ex. catalogue;
Muncie, Ball State College Art Gallery (Ball State
University Art Gallery), on loan, 1937—.

REFERENCES:
American Art Association, Anderson Galleries, Inc.
*Valuable Paintings Including the Celebrated ''Black Boy''
by Thomas Gainsborough, R. A., Fine Examples by
American Artists, Noteworthy Works of the French School.*
New York: American Art Association, 1935, sale no.
4196, November 1, 1935, lot no. 34, illustrated p. 19;
Ball State Teachers College. "Catalogue of Paintings,
Sculpture, and Other Art Objects at Ball State
Teachers College, Muncie, Indiana," *Ball State Teachers
College Bulletin*, vol. XXIII, no. 1, September 1947,
p. 13.

Unpublished: Stock Disposition Cards—Sold Pic-
tures, William Macbeth, Inc., –8423; Letter dated
March 10, 1981, Kathleen M. Burnside, research
associate, Hirschl and Adler Galleries, New York, New
York, to Dolores Terhune, assistant to the director,
Ball State University Art Gallery.

see color plate IV, p. 39

9. *Head* 1913
oil on canvas
54 × 43.8 cm, 21¼ × 17¼ inches
signed in black oil paint, upper right: *Childe Hassam
 1913*
inscribed in blue pencil, verso, pressed paper board
 backing: *#23765*
bears William H. Powell, 983 6th Avenue, New York,
 New York, stamp, verso, stretcher, upper left.

Whitewater Valley Museum of Art (Art Association
 of Richmond)
Gift of John Levy Galleries
34.2

Childe Hassam was one of only two members of The
Ten to exhibit in the critical Armory Show (*Interna-
tional Exhibition of Modern Art*) of 1913. He included six
oil paintings, five pastels and one drawing. One-third
of the thirteen hundred works chosen for the exhibi-
tion were by foreign artists, and this introduction of
European modernism—Post Impressionist and Cubist
works—altered the future directions of American art.
Hassam was invited to participate and his work was
considered sufficiently important to warrant a post
card reproduction of *Vesuvius*. Yet, even when com-
pared to some of the American artists represented, his
works were conservative.

Thus while certain works post-dating his last Euro-
pean trip in 1910 and a larger number after 1913 ex-
hibit a greater willingness to experiment with form and
color, Hassam remained solidly committed to impres-
sionism. The unifying tonality and delicate modulation
of color used in *Head* are typical of his mature work.
Here the sitter, probably Maude Hassam, stands out
against an indecipherable backdrop, yet through color
and brushwork, these two seemingly disparate areas are
unified.

CONDITION:
Very good
wax lined to canvas support, restored hole, lower left

PROVENANCE:
Childe Hassam; ? ; John Levy Galleries, New York,
New York; Art Association of Richmond (Whitewater
Valley Museum of Art), Richmond, Indiana, early
1934.

REFERENCES:
Laughlin, Sara Gaar. *Art in Richmond: 1898–1978*,
Richmond: Art Association of Richmond, 1978, il-
lustrated, unpaginated.

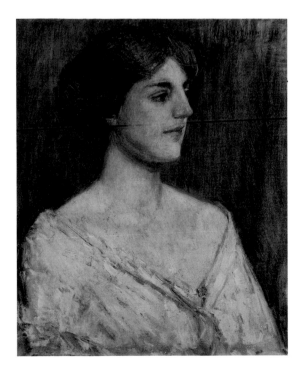

10. *The Silver Veil and the Golden Gate* 1914
oil on canvas
76.2 × 81.3 cm, 30 × 32 inches
signed in blue oil paint with red, lower right: *Childe Hassam / Sausalito 1914*
bears red bordered cream white paper label, verso, inner frame, upper center, inscribed: *The Silver Veil and the Golden Gate*
and remnant of a blue bordered cream white paper label, verso, inner frame, upper center
and Valparaiso University label, verso, inner frame, bottom center
under which is a printed card inscribed: *Call Collect 744-1129 / 159 Watchung Avenue, Montclair, New Jersey*

Sloan Collection
Valparaiso University Art Galleries and Collections
Sloan Fund
67.2

Hassam traveled to the west coast in 1908 and again in 1914. The purpose of the 1908 journey was to complete a mural commission in Portland, Oregon, for the library of Colonel and Mrs. Charles Erskin Scott Wood's home. He later joined Wood on a trip to the Harney Desert in the southern portion of the state. Hassam was one of twelve American artists honored with an exhibition in the Fine Arts pavilion at the 1915 *Panama Pacific International Exposition*, held in San Francisco. His 1914 journey to that city enabled him to

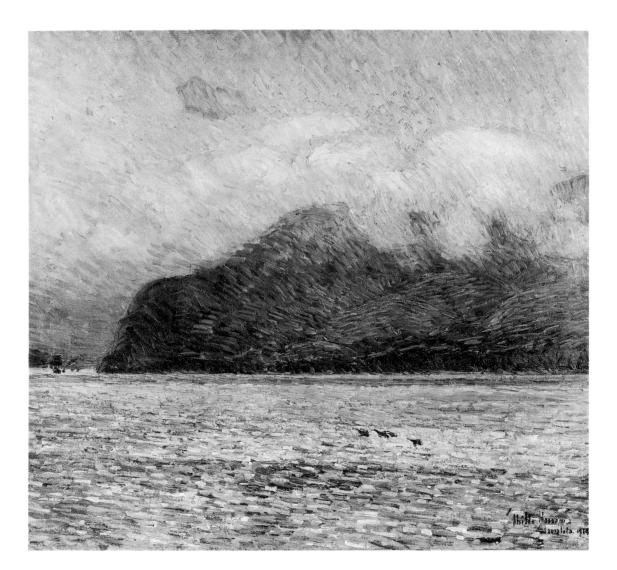

view the exhibition. The inclusion of a painting entitled *Portland, Oregon* (cat. no. 74, p. 64) in the *Inaugural Exhibition of the John Herron Art Institute* indicates an earlier, heretofore unrecorded western journey.

Hassam's response to the west bears certain similarities to those of mid-nineteenth-century American artists. Unlike the high horizon typical of his Isles Shoals landscapes wherein attention is focused on the interrelationship of sea and rocks, the works executed in Oregon and California are a response to the grandeur of open vistas. Typical of these works is a sensitivity to cloud formations and atmospheric effects as illustrated in *The Silver Veil and the Golden Gate*. The painting's dominant overall tonality and its clearly romantic outlook herald the direction of much of his later work.

The Silver Veil and the Golden Gate was one of the three hundred oils, ninety-two watercolors, and thirty-one pastels Hassam bequeathed to the American Academy of Arts and Letters at his death in 1935. The gift carried the stipulation that income derived from their sale be used to purchase works by young American and Canadian artists and that they be given to American and Canadian museums under the auspices of the Hassam Fund of the American Academy of Arts and Letters.

CONDITION:
Excellent

PROVENANCE:
Childe Hassam; Childe Hassam estate, 1935; American Academy of Arts and Letters, 1935; ? ; Milch Galleries, New York, New York, before 1964; Valparaiso University Art Galleries and Collections, March 1967.

EXHIBITIONS:
New York, Montross Gallery, Exhibition of Pictures by Childe Hassam, November 27–December 11, 1915, cat. no. 17.

REFERENCES:
The Art Quarterly, vol. 27, no. 4, 1964, p. 537, illustrated; *The Cresset*, vol. XXXV, no. 1, November 1971, p. 25, vol. XLIII, no. 1, November 1979, illustrated front cover, vol. XLV, no. 7, May 1982, p. 2; Broder, Patricia Janis. *The American West: The Modern Vision*. New York: New York Graphic Society, 1984, p. 16, illustrated in color; *The American West*, vol. XXII, no. 1, January/February, 1985, p. 35, illustrated.

11. *Kitty Hughes* 1917
(*At the Window*)
oil on canvas
76.6 × 65.8 cm, 30 × 25¾ inches
signed in brown oil paint, lower left: *Childe Hassam / 1917*
bears white paper tags, verso, stretcher, lower left, imprinted with *#39* and *#10* respectively
and blind stamp, verso, frame, lower center: *298 / 621*

Ball State University Art Gallery
Gift of Mrs. Albert J. Beveridge
41.172?

"Childe Hassam in Indiana" includes two works from the New York Window Series, a recurrent theme from the second decade of this century. A comparison of *Kitty Hughes* and *The Bowl of Goldfish* (cat. no. 8, p. 40) exemplifies the diversity of works within this series. The comparison also is indicative of the disparity between his best mature works as illustrated by *The Bowl of Goldfish* and those that are less successful.

Hassam continued to paint into the mid-1930s. Estimates of the total output from a creative life spanning six decades are as high as two thousand oils and an additional two thousand works in various media. The Flag Series, a response to the First World War executed between 1916 and 1919, must be considered among his greatest achievements during the later stages of his career. By 1915 he turned his attention increasingly to etching and drypoint and, in 1917, to lithography. Moreover, although his achievements in the graphic media are of great consequence, his paintings of the same period are of less consistent quality.

The central focus of *The Bowl of Goldfish* remains the rich landscape viewed through the open window. Hassam uses the landscape to open an otherwise shallow interior space and as a source of color and light, a device used throughout the New York Window Series. In *Kitty Hughes*, the window is curtained. Thus while it remains the source of light within the composition, the reflected space in the mirror creates illusionary depth. Unfortunately, his use of color in *Kitty Hughes* is less inspired, and it pales in comparison to *The Bowl of Goldfish*.

CONDITION:
Excellent

PROVENANCE:
Childe Hassam; probably Montross Gallery; Mrs. Marshall (Delia Spencer Caton) Field, Chicago, Illinois, before 1922; Mrs. Albert J. (Catherine Eddy) Beveridge, Indianapolis, Indiana; Ball State Teachers College Art Gallery (Ball State University Art Gallery), 1941.

EXHIBITIONS:
Muncie, Ball State University Art Gallery, *20th Century American Art from the Collections of Indiana Universities*, February 4–25, 1979, cat. no. 27.

REFERENCES:
Pousette-Dart, Nathaniel. *Distinguished American Artists: Childe Hassam*. Introduction by Ernest Haskell. New York: Frederick A. Stokes Company, 1922, unpaginated, p. 34; Ball State Teachers College. "Catalogue of Paintings, Sculpture, and Other Art Objects at Ball State Teachers College, Muncie, Indiana," *Ball State Teachers College Bulletin*, vol. XXIII, no. 1, September 1947, p. 14, as *At the Window*.

Unpublished: Letter dated March 10, 1981, Kathleen M. Burnside, research associate, Hirschl and Adler Galleries, New York, New York, to Dolores Terhune, assistant to the director, Ball State University Art Gallery.

Catalogue no. 11

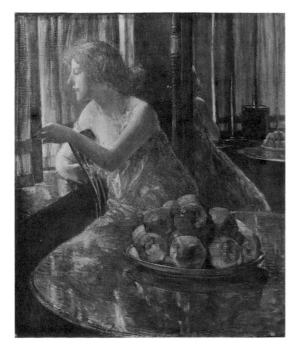

12. *Newfields, New Hampshire* August 13, 1917
watercolor on white paper
25.4 × 35.6 cm, 10 × 14 inches
signed in black watercolor, lower right: *Childe Hassam Aug 13 1917*

Indianapolis Museum of Art
Mary Milliken Fund
29.69

Hassam retained a lifelong interest in watercolor. He helped to found the New York Watercolor Club shortly after his return from Europe in 1889 and was a member of the American Watercolor Society. It is also important to note that he considered the English, as exemplified in the watercolors of Turner, Bonington, and Constable and the paintings of Constable and others, the true inventors of Impressionism. Hassam was not a studio painter in the true academic sense and rarely were preparatory studies made for finished works. His work is typically a direct response to his inspiration and, as his predominant subject matter was landscape, the majority were executed out of doors.

Newfields, New Hampshire, a small town bordering the Exeter River southwest of Portsmouth, was the subject of a number of works. A 1906 watercolor of Newfields (Currier Gallery of Art, Manchester, New Hampshire) is strikingly similar in composition to this 1917 example. In 1915, he produced an etching of the site. Each of these compositions incorporates the sense of immediacy and assured, direct execution typical of his best work.

Hassam was conscious of the need and desirability of placing his works in public collections and reduced his asking prices to make purchases by such institutions possible. In his 1906 letter to Mrs. Johnston (see p. 68) he indicates a willingness to reduce the price of *The Old Violinist* (cat. no. 73, p. 63) to coincide with the funds available to the Art Association of Richmond. *Entrance to the Siren's Grotto, Isles of Shoals* (cat. no. 5, p. 32) was acquired by the Muncie Art Association in 1907 for less than one-half of its original price, and the acquisition of *Newfields, New Hampshire* by The John Herron Art Institute in 1929 was made possible by a similar reduction.

CONDITION:
Excellent

PROVENANCE:
Childe Hassam (consigned to William Macbeth, Inc., New York, New York, January 1929, consigned by Macbeth to The John Herron Art Institute, Indianapolis, Indiana, May 1929); The John Herron Art Institute (Indianapolis Museum of Art), Indianapolis, Indiana, June 22, 1929.

EXHIBITIONS:
Indianapolis, The John Herron Art Institute, *American Paintings*, September 1932; Fort Wayne, Fort Wayne Museum of Art, *Impressionists in America*, December 8, 1966–February 8, 1967; New York, American Federation of the Arts, *From the Archives of American Art: The Role of the Macbeth Gallery*, October 10–29, 1962 (also Tampa, Tampa Art Institute, November 12–December 3, 1962; Oklahoma City, Oklahoma Art Center, December 17, 1962–January 7, 1963; Flint, Flint Institute of Arts, January 25–February 15, 1963; Columbia, South Carolina, Columbia Museum of Art, May 1–22, 1963; Rochester, Memorial Art Gallery, University of Rochester, April 5–26, 1963; Albany, Albany Art Institute, May 6–31, 1963); Tucson, University of Arizona Museum of Art, *Childe Hassam, 1859–1935*, February 5–March 5, 1972 (also Santa Barbara, Santa Barbara Museum of Art, March 26–April 30, 1972), cat. no. 101, p. 143, illustrated p. 121.

REFERENCES:
Indianapolis Museum of Art, *Catalogue of the American Paintings*, Indianapolis: Indianapolis Museum of Art, 1970, p. 146; *Bulletin of the Art Association of Indianapolis, The John Herron Art Institute*, vol. XXIII, no. 4, September 1932, p. 51, vol. XXIX, no. 2, October 1942, p. 27.

Unpublished: Letters dated May 20 and June 12, 1929, Robert Macbeth, William Macbeth, Inc., to Lucy Taggart, North Delaware Street, Indianapolis, Indiana; letter dated May 24, 1929, Robert Macbeth, William Macbeth, Inc., to Wilbur Peat, director, The John Herron Art Institute; stock disposition cards—sold pictures, William Macbeth, Inc., #4576.

13. *The English Girl* 1919
oil on canvas
76.8 x 51.4 cm, 30¼ x 20¼ inches
signed in brown oil paint, lower right: *Childe Hassam 1919*
bears Grand Central Art Galleries label, verso, frame, stamped: *#102*
and Sotheby Parke Bernet labels, verso, frame and backing board: *sale no. 4098 / lot no. 37*
and Babcock Galleries stamp, verso, frame, upper center
and Babcock Galleries label, verso, backing board, imprinted: *11774—Childe Hassam, oil 1919. "The English Girl."*
and New Orleans Museum of Art label, verso, backing board
and Fine Arts Gallery of San Diego label, verso, backing board
and McNay Art Institute label, verso, backing board

and Gallery 100, Mishawaka, Indiana, label, verso, backing board
and North Carolina Museum of Art label, verso, backing board

Midwest Museum of American Art, Elkhart, Indiana
Anonymous Extended Loan
79.05.05 EL

Not included in exhibition

The English Girl is representative of the best works from Hassam's later life. Although it does not incorporate any of the modernist tendencies toward abstraction of form and color that appear occasionally after his last European journey (and more often after the Armory Show of 1913), it remains a sound achievement within the American Impressionist aesthetic. Here Hassam combines the vigorous brushwork and the resultant emphasis in a more decorative surface typical of his paintings from the late 1890s and early 1900s within a clearly tonal composition of muted and delicate color.

Like *Kitty Hughes* (cat. no. 11, p. 43), the picture space is shallow. Yet here he opens the composition indirectly by turning the figure away from the viewer and alluding to a relationship between the figure, the rose, and the space behind and to the left of the frame.

Unfortunately, it was not possible to include *The English Girl* in this exhibition. Nonetheless, it is catalogued and illustrated here in order to afford the reader complete documentation on Childe Hassam works in Indiana public collections.

CONDITION:
Excellent

PROVENANCE:
Childe Hassam; William Macbeth, Inc.; William J. Johnson, St. Davids, Pennsylvania, before December 1924; Faragil Galleries, New York, New York; Babcock Galleries, New York, New York, circa 1960; Grand Central Art Galleries, New York, New York; John J. McDonough, Youngstown, Ohio, 1965; Gallery 100, Mishawaka, Indiana, March 30, 1978; Richard D. Burns, Elkhart, Indiana, 1978.

EXHIBITIONS:
Buffalo, Buffalo Fine Arts Academy, Albright Art Gallery, *Catalogue of the Retrospective Exhibition of Paintings Representative of the Life Work of Childe Hassam, N. A.*, March 9–April 8, 1929, cat. no. 88; New York, Babcock Galleries, *Childe Hassam*, November 7–December 3, 1960, cat. no. 23; New Orleans, New Orleans Museum of Art, *A Panorama of American Paintings: The John J. McDonough Collection*, introduction, E. J. Bulland, April 18–June 8, 1975 (also San Diego, Fine Arts Gallery of San Diego, June 30–August 10, 1975; San Antonio, Marian Koogler McNay Art Institute, September 12–October 19, 1975; Little Rock, Arkansas Arts Center, November 14–December 28, 1975; Greensburg, Pennsylvania, The Westmoreland County

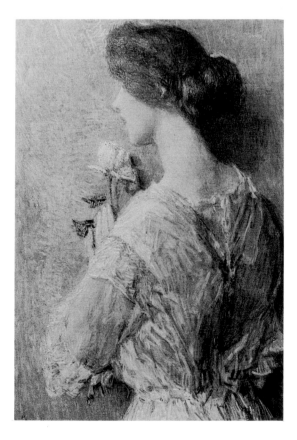

Museum of Art, January 26–March 8, 1976; Raleigh, The North Carolina Museum of Art, April 6–June 1, 1976; Oklahoma City, Oklahoma Art Center, July 1–August 5, 1976; Youngstown, Ohio, The Butler Institute of American Art, October 3–31, 1976), cat. no. 20; Elkhart, Indiana, Midwest Museum of American Art, on loan, 1979–; Elkhart, Indiana, Midwest Museum of American Art, *Panorama of American Art*, May 1979.

REFERENCES:
Price, F. Newton. "The Johnsons of Uniontown," *International Studio*, vol. LXXX, no. 331, December 1924, p. 199; Parke Bernet Galleries, Inc. *English and French Furniture and Decorations, Georgian Silver, Paintings, Table Porcelain, Oriental Rugs.* New York: Parke Bernet Galleries, Inc., 1947, sale no. 828, January 15–18, 1947, lot no. 433, illustrated; Bullard, E. J. *A Panorama of American Paintings: The John J. McDonough Collection.* New Orleans, New Orleans Museum of Art, 1975, pp. 31–32, 96, illustrated, plate 38, p. 96; Sotheby Parke Bernet, Inc. *The Collection of John J. McDonough, Youngstown, Ohio.* New York: Sotheby Parke Bernet, Inc., 1978, sale no. 4098, March 22, 1978, lot no. 37, illustrated in color.

Unpublished: Updated inventory list, written by Childe Hassam, of twenty-seven works. William Macbeth, Inc., papers, no. 13. English Girl.

Catalogue no. 14

Attributed to Childe Hassam

14. *Boulevard Café, Paris* undated
oil with some pencil underdrawing on pressed paper board
21.5 × 21.1 cm, 8⅜ × 8¼ inches
unsigned
painted black, verso
bears remnants of black bordered white paper labels, verso, upper center and lower center
and white paper label, verso, backing board, center, typed: *Oil / Boulevard Cafe—Paris / Hassam 18″ × 8″ / Keene gift on 12-2-58 / Appraisal value $850 / #52*
and on the same label, in black ink: *$6000.00 {1971 C.J.W.*

Shortridge High School Collection
Indiana State Museum
Gift of T. Victor Keene

Although attributed to Childe Hassam upon its donation to Shortridge High School in 1958 and in all probability when originally acquired by Keene, *Boulevard, Café Paris* is unsigned and bears no identifying marks. The painting was executed somewhat hesitantly, using a heavy impasto of Post-Impressionistic colors. The composition is not particularly inspired and the drawing indicating facial detail is unresolved. The scene is apparently European. The work is certainly post-1900 and was probably executed between 1910 and 1920. Stylistically the painting has little in common with Hassam's mature work.

While there are many unanswered questions concerning *Boulevard, Café Paris*, it remains extremely doubtful that its attribution to Childe Hassam is correct. Rather, the work is included herein because of its longstanding attribution and the inevitable questions that would have been raised by its absence.

CONDITION:
Good

PROVENANCE:
? ; T. Victor Keene, Indianapolis, Indiana; Shortridge High School, Indianapolis, Indiana, December 2, 1958.

EXHIBITIONS:
Indianapolis, Indianapolis Museum of Art, on loan, March 16, 1971–September 1985; Indianapolis, Indiana State Museum, on loan, September 1985—.

Catalogue of Etchings, Drypoints, and Lithographs

Title: Information within parentheses refers to the sitter, place, etc.

Edition: Unless otherwise indicated all prints are of the only known state. Information on the number of impressions taken has been obtained from the *catalogues raisonnés* of Hassam's printed work (see references).

Dimensions: Where possible, all dimensions have been taken from the actual work. Two sets of dimensions indicate image and support in that order.

Inscriptions: Except where indicated, inscriptions appear on the plates. Signatures are noted as such. The use of a virgule indicates a second line within the same inscription. The letters LL (lower left), UR (upper right), etc. refer to area within the plate or immeduately adjacent to it. The letters BL (bottom left), BR, etc. refer to the margins.

References: References appear in abbreviated form. A complete bibliography can be found on page 71.

BAM

Etchings and Drypoints

15. *The Laurel Wreath* 1907–1915
etching on medium-weight wove paper
20 proofs, plate destroyed
23.3 × 12.6 cm, 9³⁄₁₆ × 4¹⁵⁄₁₆ inches
26.8 × 18.5 cm, 10⁹⁄₁₆ × 7⁵⁄₁₆ inches
signed LL: / 1907
and in pencil LR: *CH* imp
inscribed in pencil BC: *Laurel Wreath*

Indianapolis Museum of Art
Gift of Mrs. Childe Hassam
40.121

REFERENCES:
Cortissoz no. 5; Clayton no. 5, The Group of Nudes.

16. *The Dutch Door* 1915
(Helen Burke at door of Holley House, Cos Cob,
 Connecticut)
etching on medium-weight wove paper
plate destroyed
21.5 × 25.8 cm, 8½ × 10⅛ inches
24 × 29.8 cm, 9⁷⁄₁₆ × 11¾ inches
signed UL: *CH* / 1915
and in pencil LR: *CH* imp
inscribed in pencil BR: *Dutch Door 75*

Indianapolis Museum of Art
Gift of Miss Lucy M. Taggart
29.66

REFERENCES:
Cortissoz no. 49; Clayton no. 49, The New England
Group.

Catalogue no. 16

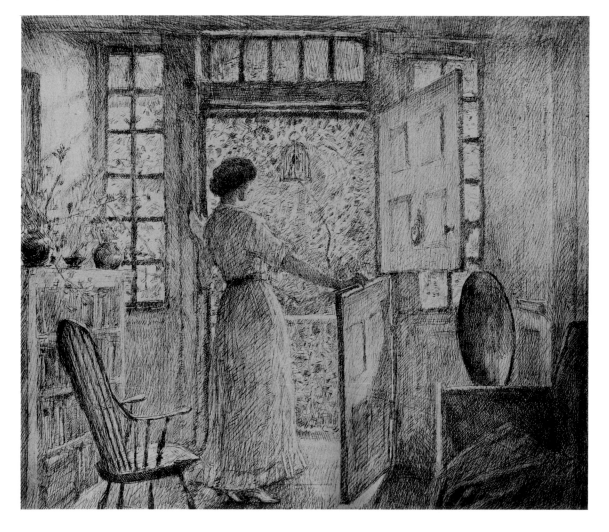

16a. *The Greek Dance* 1916
etching
(This earlier pencil signed impression appears on the
 verso of cat. no. 16)

REFERENCES:
Cortissoz no. 91; Clayton no. 91.

17. *The White Mantel* 1915
(Helen Burke in dining room of Holley House, Cos
 Cob, Connecticut)
etching on light blue light-weight wove paper
17.5 × 25 cm, 6⅞ × 9⅞ inches
21.7 × 28.9 cm, 8½ × 11⅜ inches
signed in pencil LR: *CH* imp
inscribed in pencil BL: *The White Mantel*

Ball State University Art Gallery
Gift of Mrs. Childe Hassam
000.198.12

REFERENCES:
Cortissoz no. 50; Clayton no. 50, The New England
 Group.

18. *Reading in Bed* 1915
(Mrs. Hassam in New York apartment)
etching on heavy-weight wove paper
17.6 × 13.7 cm, 6⅞ × 5⅜ inches
30.5 × 16 cm, 12 × 6⁵⁄₁₆ inches
signed LL: *CH*
and in pencil LR: *CH* imp
inscribed in pencil BL: *Reading in Bed*

Ball State University Art Gallery
Gift of Mrs. Childe Hassam
000.198.8

REFERENCES:
Cortissoz no. 28; Clayton no. 28.

19. *The Laurel Dance* 1915
(From a note taken at a festival at Mt. Kisco, New
 York, June 1915)
etching on medium-weight wove paper
17.6 × 17.6 cm, 6¹⁵⁄₁₆ × 6¹⁵⁄₁₆ inches
29.6 × 42.7 cm, 11⅝ × 16¹³⁄₁₆ inches

Catalogue no. 17

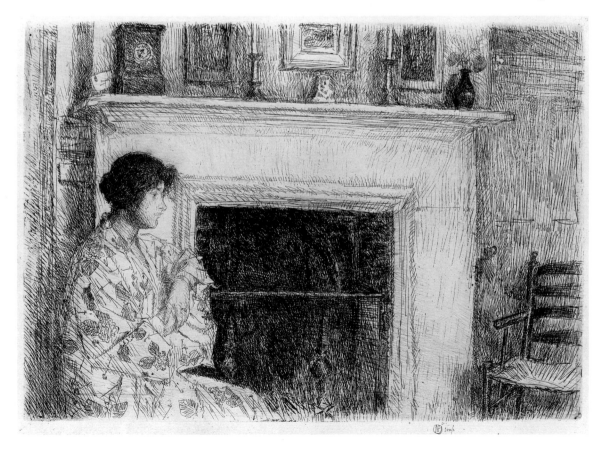

signed LR: *⊘* / 1915
and in pencil LR: *⊘* *imp*
inscribed in pencil BL: *The Laurel Dance*

Indianapolis Museum of Art
Gift of Mrs. Childe Hassam
40.112

REFERENCES:
Cortissoz no. 22; Clayton no. 22, The Group of Nudes.

20. *Long Ridge* September 28, 1915
(Approximately fourteen miles inland from Cos Cob,
 Connecticut)
etching on light-weight wove paper
15 proofs, plate destroyed
18.8 × 22.6 cm, 7⅜ × 8⅞ inches
22.3 × 27 cm, 8¾ × 10⅝ inches
signed LC: *Sept. 28 / Long Ridge / ⊘ / 1915*
and in pencil LR: *⊘* *imp*
inscribed in pencil BL: *Long Ridge*

Indianapolis Museum of Art
Gift of Mrs. Childe Hassam
40.119

REFERENCES:
Cortissoz no. 42; Clayton no. 42, The New England
Group.

21. *Toby's, Cos Cob* October 31, 1915
(Toby Burke's bar at Cos Cob, Connecticut)
etching on medium-weight wove paper
plate destroyed
17.6 × 22.7 cm, 6⅞ × 8⅞ inches
24.1 × 32 cm, 9½ × 12⁹/₁₆ inches
signed LL: *Cos Cob / ⊘ / 1915 / Oct. 31*
and in pencil LR: *⊘* *imp*

Ball State University Art Gallery
Elisabeth Ball Collection, Gift of the George and
 Frances Ball Foundation
83.33.10

REFERENCES:
Cortissoz no. 55; Clayton no. 55, The New England
Group.

22. *Old Lace* November 5, 1915
(Bridge at Cos Cob, Connecticut)
etching on medium-weight wove paper
plate destroyed
17.6 × 17.6 cm, 7 × 7 inches
31.8 × 24.2 cm, 12⁹/₁₆ × 9⁹/₁₆ inches
signed LR: *Cos Cob / Nov 5 ⊘ / 1915*
and in pencil LR: *⊘* *imp*
inscribed in pencil BR: *42*
and in pencil BL: *Old Lace*

Ball State University Art Gallery
Elisabeth Ball Collection, Gift of the George and
 Frances Ball Foundation
83.33.4

REFERENCES:
Cortissoz no. 56; Clayton no. 56, The New England
Group.

23. *Union Square* 1916
(From drawing of 1896)
etching on light-weight laid paper, margins trimmed
10.7 × 14.5 cm, 4¼ × 5¾ inches
signed LR: *New York / ⊘ / 1896*
inscribed in pencil, verso, LC: *Union Square N.Y.*

Ball State University Art Gallery
Gift of Mrs. Childe Hassam
000.198.9

REFERENCES:
Cortissoz no. 89; Clayton no. 89, The New York Set.

24. *Manhattan* February 1916
(From September 1911 drawing made from the Hotel
 Touraine, Brooklyn)
etching on light-weight laid antique ledger paper
13.9 × 25.7 cm, 5½ × 10⅛ inches
19.1 × 31.5 cm, 7½ × 12⅜ inches
signed LL: *Manhattan / ⊘*
and in pencil LR: *⊘* *imp*
inscribed in pencil BL: *Manhattan*

Indianapolis Museum of Art
Gift of Mrs. Childe Hassam
40.120

REFERENCES:
Cortissoz no. 69; Clayton no. 69, The New York Set.

25. *Washington's Birthday—Fifth Avenue and 23rd
 Street* February 22, 1916
etching, second and final state, on medium weight
 laid paper
32.6 × 17.7 cm, 12⅞ × 7 inches
40.2 × 25.2 cm, 15¹³/₁₆ × 9¹⁵/₁₆ inches
signed LL: *New York / ⊘ / Feb. 22 1916*
and in pencil LR: *⊘* *imp*
inscribed in pencil BL: *Washington's Birthday*

Ball State University Art Gallery
Gift of Mrs. Childe Hassam
000.198.10

REFERENCES:
Cortissoz no. 68; Clayton no. 68, The New York Set.

26. *Fifth Avenue, Noon* April 1, 1916
(From a window at 5th Avenue and 34th Street)
etching, first state of two, on light-weight wove paper
approximately 20 proofs
24.8 × 19 cm, 9¾ × 7½ inches
34.5 × 21.1 cm, 13⁹∕₁₆ × 8⁵∕₁₆ inches
signed LL: *April 1 /* CH */ 1916*
and in pencil LR: CH *imp*

Ball State University Art Gallery
Elisabeth Ball Collection, Gift of the George and
 Frances Ball Foundation
83.33.6

REFERENCES:
Cortissoz no. 77; Clayton no. 77, The New York Set.

27. *Fifth Avenue, Noon* April 1, 1916
etching, second state
24.8 × 18.3 cm, 9¾ × 7³∕₁₆ inches
signed LL: *April 1 /* CH */ 1916*
and in pencil LR: CH *imp*

Sloan Collection, Valparaiso University Art Galleries
 and Collections, Valparaiso, Indiana. Sloan Fund.
83.11

REFERENCES:
Cortissoz no. 77; Clayton no. 77, The New York Set.

Catalogue no. 22

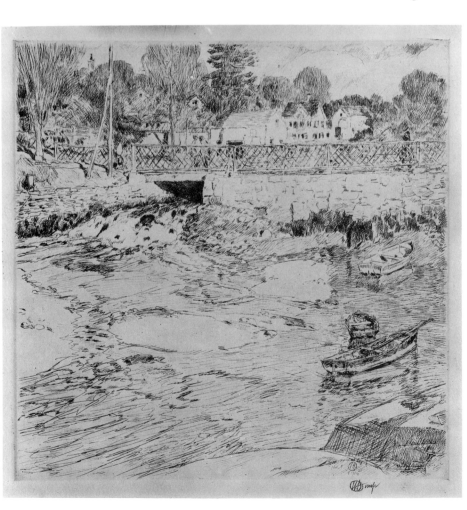

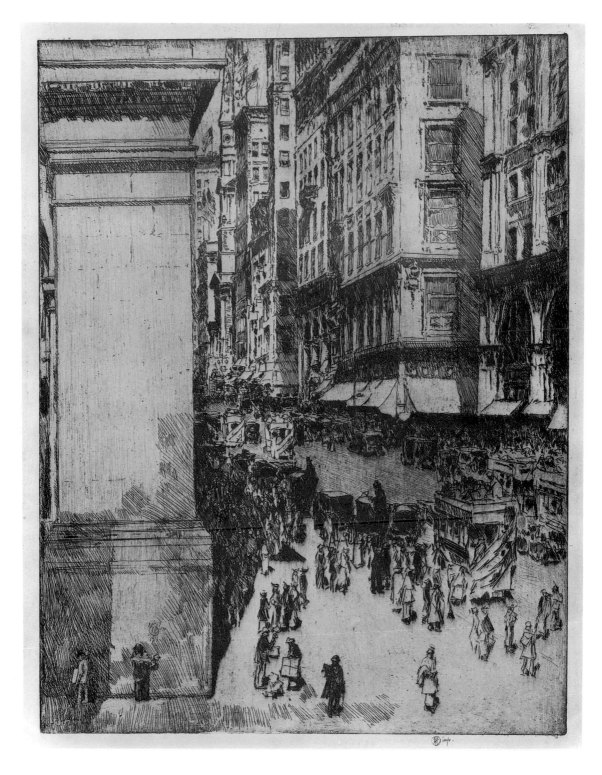

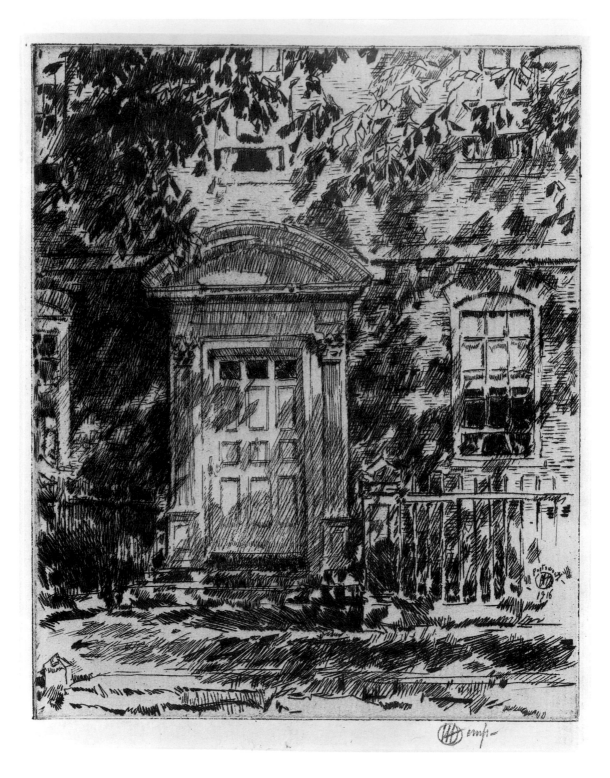

28. *Portsmouth Doorway* August 1916
(The Warner House at Portsmouth, New Hampshire)
etching on light-weight laid paper
plate destroyed
13.8 × 11.3 cm, 5½ × 4⁷⁄₁₆ inches
14.6 × 11.7 cm, 5¾ × 4⅝ inches
signed LR: *Portsmouth* / ⓒⒽ / *1916*
and in pencil LR: ⓒⒽ *imp*

Ball State University Art Gallery
Elisabeth Ball Collection, Gift of the George and
 Frances Ball Foundation
83.33.8

REFERENCES:
Cortissoz no. 104; Clayton no. 104, The New England
Group.

29. *Diana's Pool, Appledore* 1916
(Appledore, Isles of Shoals, Maine)
etching on antique medium-weight laid paper
plate destroyed
27.3 × 18.8 cm, 10¹⁵⁄₁₆ × 7⅛ inches
33.7 × 28.7 cm, 13¼ × 11⁵⁄₁₆ inches
signed LR: ⓒⒽ / *1916*
and in pencil LR: ⓒⒽ *imp*

Ball State University Art Gallery
Gift of Mrs. Childe Hassam
000.198.2

REFERENCES:
Cortissoz no. 98; Clayton no. 98, The Group of Nudes.

30. *Madonna of the North End* 1916
(From drawing of the "North End" of Boston)
etching on light-weight wove paper
16.6 × 10.5 cm, 6½ × 4⅛ inches
25.5 × 19 cm, 10¹⁄₁₆ × 7½ inches
signed UL: ⓒⒽ / *1916*
and in pencil LR: ⓒⒽ *imp*
inscribed in pencil BL: *Madonna of the North End*

Indianapolis Museum of Art
Gift of Mrs. Childe Hassam
40.122

REFERENCES:
Cortissoz no. 100; Clayton no. 100, The New England
Group.

31. *The Flag* May 2, 1917
(5th Avenue at 56th Street, New York City)
etching on medium-weight wove paper
7 proofs, plate destroyed
13.3 × 10.7 cm, 5¼ × 4¼ inches
19.5 × 12.3 cm, 7¹¹⁄₁₆ × 4⅞ inches
signed LL: *New York* / ⓒⒽ / *May 2nd* / *1917*
and in pencil LR: ⓒⒽ *imp*
inscribed in pencil BL: *The Flag*
and in pencil BR: *24*

Ball State University Art Gallery
Gift of Mrs. Childe Hassam
000.198.4

REFERENCES:
Cortissoz no. 131; Clayton no. 131, The New York Set.

Catalogue no. 29

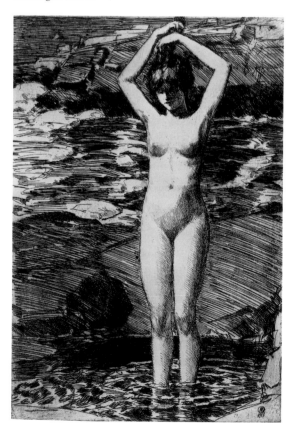

46. *Egeria* June 2, 1929
etching on light-weight wove paper
12.8 × 17.6 cm, 5 × 6¹⁵⁄₁₆ inches
29.5 × 22.8 cm, 11⅝ × 9 inches
signed LR: *June 2nd /* 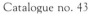 */ 1929*
and in pencil LR: 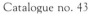 *imp*
inscribed in pencil BL: *Egeria*

Indianapolis Museum of Art
Gift of Mr. John G. Rauch
61.47

REFERENCES:
Clayton no. 324, The Group of Nudes.

47. *New York, 1931* March 21, 1931
(View from the artist's studio window)
etching on light-weight laid paper
32.7 × 26.1 cm, 12⅞ × 10¼ inches
42.4 × 29.8 cm, 16¾ × 11¾ inches
signed LR: *5 p.m. / New York / March 21 /* 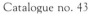 */
 1931*
and in pencil LR: 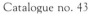 *imp*
inscribed in pencil BL: *N. Y.—Spring 1931*

Indianapolis Museum of Art
Gift of Mrs. Childe Hassam
 40.113

REFERENCES:
Clayton no. 336, The New York Set.

Catalogue no. 43

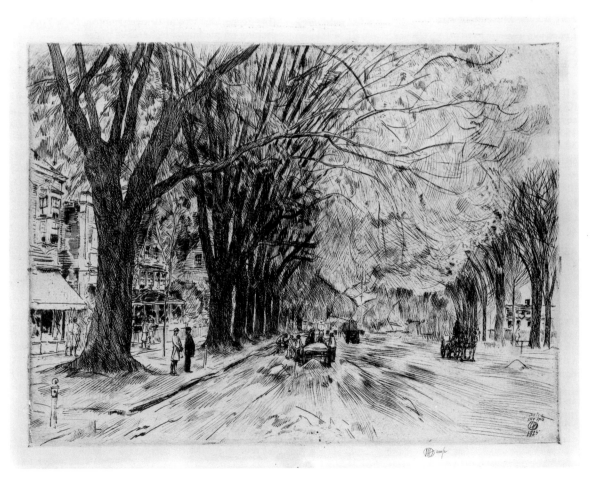

48. *The Heart of Easthampton* October 17, 1931
(Easthampton, New York)
etching on light-weight laid paper
19.1 × 38.7 cm, 7½ × 15¼ inches
24.5 × 47.6 cm, 9⅝ × 18¾ inches
signed LL: (CH) *Oct 17th 1931 4:30 pm / Easthampton
 Ll.*
and in pencil LR: (CH) *imp*
inscribed in pencil BL: *The Heart of Easthampton*

Ball State University Art Gallery
Gift of Mrs. Childe Hassam
000.198.5

REFERENCES:
Clayton no. 348, The Easthampton Set.

49. *Mt. Vernon* January 16, 1932
etching, second and final state, on medium-weight
 wove paper
(First state published as *Washington's Home, Mt.
 Vernon*, April, 1925)
21.3 × 30.5 cm, 8⅜ × 12 inches
29.1 × 38.6 cm, 11⁷⁄₁₆ × 15³⁄₁₆ inches
signed LC: *Jan 16 / 2nd* (CH) *State / 1932*
and LR: *April / MT. Vernon /* (CH) * / 1925*
and in pencil LR: (CH) *imp*
inscribed in pencil BL: *Jan. 1932 2nd State
 Washington's Home*

Ball State University Art Gallery
Gift of Mrs. Childe Hassam
000.198.11

REFERENCES:
Clayton no. 350, The South and West Group.
A duplicate impression is in the Indianapolis Museum
of Art.

Lithographs

50. *North River* 1917
lithograph on light-weight wove paper
edition of 95
29.5 × 28 cm, 11⅝ × 11 inches
38 × 30.9 cm, 15 × 12³⁄₁₆ inches
signed LR: *Childe Hassam 1917*
and in pencil LR: (CH) *imp*
inscribed in pencil BL: *North River*
and in green pencil BL encircled: *1624*

Indianapolis Museum of Art
Gift of Mrs. Childe Hassam
40.127

REFERENCES:
Griffith no. 1.

51. *New York Bouquet* November 14, 1917
lithograph on light-weight wove paper
edition of 93
28 × 16 cm, 11 × 6⁵⁄₁₆ inches
41 × 27.5 cm, 16⅛ × 10¹³⁄₁₆ inches
signed LL: *Childe Hassam / Nov. 14th, 1917*
and in pencil LL: (CH) *imp*
inscribed in pencil BL: *New York Bouquet*
and in green pencil BL encircled: *1459*

Indianapolis Museum of Art
Gift of Mrs. Childe Hassam
40.132

REFERENCES:
Griffith no. 2.

52. *Joseph Pennell* 1917
lithograph on light-weight wove paper
edition of 83
38.5 × 29 cm, 15⅛ × 11⁷⁄₁₆ inches
44.4 × 30.8 cm, 17⅛ × 12⅛ inches
signed LR: *Childe Hassam 1917*
and in pencil LC: (CH)
inscribed in pencil BL: *Joseph Pennell*
and in green pencil BL encircled: *1674*

Indianapolis Museum of Art
Gift of Mrs. Childe Hassam
40.128

REFERENCES:
Griffith no. 3.

53. *St. Thomas, New York* 1918
lithograph on light-weight wove paper
edition of 62
27.4 × 20.8 cm, 10¹³⁄₁₆ × 8³⁄₁₆ inches
41.6 × 29 cm, 16⅜ × 11 7/16 inches
signed LL: (CH) *1918*
and in pencil LC: (CH)
inscribed in pencil BL: *St. Thomas, New York*

Ball State University Art Gallery
Gift of Mrs. Childe Hassam
000.198.22

REFERENCES:
Griffith no. 4.

54. *Lafayette Street* 1918
lithotint on light-weight wove paper
edition of 59
36.5 × 28 cm, 14⅜ × 11 inches
45.4 × 29.6 cm, 17⅞ × 11¹¹/₁₆ inches
signed LR: *Childe Hassam / 1918*
and LR: *⊂ℋ⊃ / IIX*
and in pencil LR: *⊂ℋ⊃*
inscribed in pencil BL: *Lafayette Street*

Ball State University Art Gallery
Gift of Mrs. Childe Hassam
000.198.16

REFERENCES:
Griffith no. 5.

55. *Mrs. Hassam Knitting* 1918
(Large version)
lithograph on light-weight wove paper
edition of 60
31.2 × 22.5 cm, 12¼ × 8⅞ inches
45.2 × 28.9 cm, 17¹³/₁₆ × 11⅜ inches
signed LL: *⊂ℋ⊃ / 1918*
and in pencil LR: *⊂ℋ⊃*
inscribed in pencil BL: *Mrs Hassam Knitting*

Ball State University Art Gallery
Gift of Mrs. Childe Hassam
000.198.17

REFERENCES:
Griffith no. 6.

56. *Virginia* April 23, 1918
lithograph on light-weight wove paper
edition of 44
31.2 × 29 cm, 12¼ × 11⁷/₁₆ inches
43.5 × 31.1 cm, 17⅛ × 12¼ inches
signed LL: *April 23 / ⊂ℋ⊃ / 1918 / Virginia 11*

and in pencil LR: *⊂ℋ⊃*
inscribed in pencil BL: *Virginia*
and in green pencil BL encircled: *1996*

Indianapolis Museum of Art
Gift of Mrs. Childe Hassam
40.133

REFERENCES:
Griffith no. 10.

57. *New York Skyline, Dark Buildings* 1918
lithograph on light-weight wove paper
edition of 52
20.2 × 34.9 cm, 7¹⁵/₁₆ × 13¾ inches
25.6 × 45.6 cm, 10¹/₁₆ × 17¹⁵/₁₆ inches
signed LL: *Childe Hassam 1918*
and in pencil LR: *⊂ℋ⊃*
inscribed in pencil BL: *New York Skyline, Dark
 Buildings*

Ball State University Art Gallery
Gift of Mrs. Childe Hassam
000.198.20

REFERENCES:
Griffith no. 11.

58. *French Cruiser* 1918
lithotint on light-weight wove paper
edition of 54
21.8 × 32.6 cm, 8⁹/₁₆ × 12¹³/₁₆ inches
28.3 × 45.5 cm, 11⅛ × 17¹⁵/₁₆ inches
signed LR: *Childe Hassam May 18 (?) 1918*
and in pencil LR: *⊂ℋ⊃*
inscribed in pencil BL: *French Cruiser*
and in green pencil BL encircled: *669*

Indianapolis Museum of Art
Gift of Mrs. Childe Hassam
40.125

REFERENCES:
Griffith no. 13.

59. *Inner Harbor* 1918
lithograph on light-weight wove paper
edition of 104
18.3 × 29.1 cm, 7³/₁₆ × 11⁷/₁₆ inches
26.7 × 42.9 cm, 10½ × 16⅞ inches
signed LL: *Childe Hassam / Gloucester 1918*
and in pencil LL: *⊂ℋ⊃*
inscribed in pencil BL: *Inner Harbor*

Ball State University Art Gallery
Gift of Mrs. Childe Hassam
000.198.18

REFERENCES:
Griffith no. 16.

Catalogue no. 58

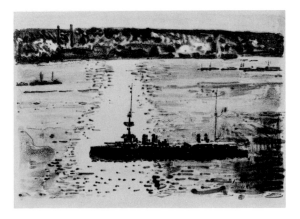

60. *Little Schoolhouse, Land of Nod* June 1918
lithograph on light-weight wove paper
edition of 55
21.9 × 31.6 cm, 8⅝ × 12⁷⁄₁₆ inches
28.7 × 45.6 cm, 11⅝₁₆ × 17¹⁵⁄₁₆ inches
signed LL: *Childe Hassam / Land of Nod June 1918*
and in pencil LR: Ⓒ⃝Ⓗ
inscribed in pencil BL: *Little Schoolhouse, Land of Nod*
and in green pencil BL encircled: *723*

Indianapolis Museum of Art
Gift of Mrs. Childe Hassam
40.131

REFERENCES:
Griffith no. 19.

61. *The Land of Nod* June 11, 1918
lithograph on light-weight wove paper
edition of 52
21.2 × 27.7 cm, 8⅜ × 10¹⁵⁄₁₆ inches
29.1 × 42.9 cm, 11½ × 16⅞ inches
signed LR: *Childe Hassam / June 11th 1918*
and in pencil LR: Ⓒ⃝Ⓗ
inscribed in pencil BL: *Land of Nod*

Ball State University Art Gallery
Gift of Mrs. Childe Hassam
000.198.19

REFERENCES:
Griffith no. 20.

62. *Deshabille* June 18, 1918
lithograph on light-weight wove paper
edition of 56
30.5 × 22.5 cm, 12 × 8⅞ inches
45.6 × 29.2 cm, 17¹⁵⁄₁₆ × 11½ inches
signed LC: *Childe Hassam June 18th 1918*
and in pencil LR: Ⓒ⃝Ⓗ
inscribed LC: *Muse*

Ball State University Art Gallery
Gift of Mrs. Childe Hassam
000.198.15

REFERENCES:
Griffith no. 14.

63. *The Spar Shop, Gloucester* July 8, 1918
(East Gloucester, Massachusetts)
lithograph on light-weight wove paper
edition of 95
20.2 × 30.9 cm, 7¹⁵⁄₁₆ × 12³⁄₁₆ inches
29 × 43 cm, 11⁷⁄₁₆ × 16¹⁵⁄₁₆ inches
signed LL: *Childe Hassam / E. Gloucester July 8, 1918*
and in pencil LC: Ⓒ⃝Ⓗ
inscribed in pencil BL: *Spar Shop*

Ball State University Art Gallery
Gift of Mrs. Childe Hassam
000.198.21

REFERENCES:
Griffith no. 23.
A duplicate impression is in the Indianapolis Museum
of Art.

64. *The Service Flag* July 21, 1918
lithograph on light-weight wove paper
edition of 52
22.8 × 15 cm, 8¹⁵⁄₁₆ × 5⅞ inches
28.6 × 22.9 cm, 11¼ × 9 inches
signed LL: *Childe Hassam July 21, 1918*
and in pencil LR: Ⓒ⃝Ⓗ
inscribed LR: *Rusby Neck ?*
and in pencil BL: *Service Flag*

Ball State University Art Gallery
Gift of Mrs. Childe Hassam
000.198.23

REFERENCES:
Griffith no. 24.

65. *The Wild Cherry Tree* 1918
lithograph on light-weight wove paper
edition of 57
27 × 28.7 cm, 10⅝ × 11¼ inches
34.2 × 44.3 cm, 13⁷⁄₁₆ × 17⁷⁄₁₆ inches
signed LR: *Childe Hassam 1918*
and in pencil LR: Ⓒ⃝Ⓗ
inscribed in pencil BL: *The Wild Cherry Tree*

Ball State University Art Gallery
Gift of Mrs. Childe Hassam
000.198.24

REFERENCES:
Griffith no. 37.
A duplicate impression is in the Indianapolis Museum
of Art.

66. *Nude* 1918
lithograph on light-weight wove paper
edition of 55
36.5 × 25 cm, 14⅜ × 9¹³⁄₁₆ inches
45 × 27.7 cm, 17¾ × 10⅞ inches
signed LL: *Childe Hassam / 1918*
and in pencil LR: Ⓒ⃝Ⓗ
inscribed in pencil BL encircled: *758*
and in pencil BL: *Nude*
and in green pencil BL encircled: *758*

Indianapolis Museum of Art
Gift of Mrs. Childe Hassam
40.129

REFERENCES:
Griffith no. 38.
Verso bears partial cancelled impression of *Joseph
Pennell*, Griffith no. 3.

67. *Colonial Church, Gloucester* September 4, 1918
(Gloucester, Massachusetts)
lithograph on light-weight wove paper
edition of 101
34.3 × 26.2 cm, 13½ × 10¼ inches
45.2 × 31.5 cm, 17¹³/₁₆ × 12⅛ inches
signed LR: *Childe Hassam / Gloucester Sept. 4th 1918*
and in pencil LR: CH
inscribed in pencil BL: *Colonial Church, Gloucester*
and in pencil BC: *318077*
and in pencil BR: *7725 18–*
and in green pencil BL encircled: *226*

Ball State University Art Gallery
Elisabeth Ball Collection, Gift of the George and
 Frances Ball Foundation
83.33.7

REFERENCES:
Griffith no. 41.
Duplicate impressions are in the Indianapolis Museum
of Art and the Ball State University Art Gallery.

68. *Afternoon Shadows* September 12, 1918
lithograph on light-weight wove paper
edition of 53
18.5 × 28 cm, 7¼ × 11 inches
23.7 × 37.5 cm, 9⁵/₁₆ × 14¾ inches
signed LR: *Childe Hassam Sept. 12th 1918*
and in pencil LR: CH
inscribed in pencil BL: *Afternoon Shadows*

Ball State University Art Gallery
Gift of Mrs. Childe Hassam
000.198.13

REFERENCES:
Griffith no. 42.
A duplicate impression is in the Indianapolis Museum
of Art.

Catalogue no. 65

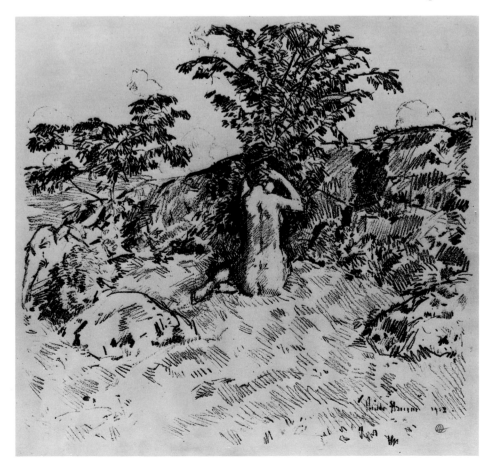

Works Exhibited in Indiana, 1900–1929

The inadequacies of catalogue documentation early in the century make it impossible to trace many of these works with certainty. The task is complicated by Hassam's output of nearly four thousand works in various media and the unfortunate alterations and rewording of titles that inevitably take place over a work's lifetime. The forthcoming *catalogue raisonné* by Stuart Feld and Kathleen Burnside will undoubtedly assist in documenting these works.

Entries are listed chronologically by date of exhibition.

AGJ

69. *The White Dory* 1895
oil on canvas
66.4 × 53.7 cm, 26 × 21 inches
signed, lower left: *Childe Hassam 1895*

PROVENANCE:
Childe Hassam (owned through June 1900); ? ; Vose Galleries, Inc., Boston, Massachusetts (in hand September 6, 1967); private collection, New Hampshire.

EXHIBITIONS:
Richmond, Art Association of Richmond, *The Fourth Annual Exhibition of the Richmond Art Association, Held at the Garfield Elementary School Building*, June 11–26, 1900, cat. no. 87.

REFERENCES:
Unpublished: Frick Art Reference Library, New York, New York, Childe Hassam, photograph no. 127-1 B.

70. *June Morning* before June 1900
probably oil on canvas

PROVENANCE:
Childe Hassam (owned through June 1900); ? .

EXHIBITIONS:
Richmond, Art Association of Richmond, *The Fourth Annual Exhibition the Richmond Art Association, Held at the Garfield School Building*, June 11–26, 1900, cat. no. 88.

71. *Sunset in the Mist (Isles of Shoals)* before June 1901
probably oil on canvas

PROVENANCE:
Childe Hassam (owned through June 1901, offered for sale at $350); ? .

EXHIBITIONS:
Richmond, Art Association of Richmond, *Fifth Annual Exhibition of the Richmond Art Association, Held at the Garfield School Building*, June 11–25, 1901, cat. no. 66.

72. *Summer* circa 1892
oil on canvas
51 × 61.2 cm, 20 × 24 inches

PROVENANCE:
Childe Hassam (owned through January 1902); ? .

EXHIBITIONS:
Philadelphia, Art Club of Philadelphia, 1892; Buffalo, *Pan American Exposition*, Department of Fine Arts, 1901, cat. no. 559; Muncie, *Art Students League, Annual Exhibition*, January 17–February 4, 1902.

REFERENCES:
The Evening Times, vol. 30, no. 102, January 27, 1902, p. 1.
 Unpublished: Letters dated October 28, 1901, and December 1, 1901, Childe Hassam, 139 West 55th Street, New York, New York, to Mrs. George A. Ball, Muncie, Indiana.

73. *Brittany Cottage* 1897
(*A Brittany Cottage*)
oil on canvas (panel?)
54.6 × 45.7 cm, 21½ × 18 inches

PROVENANCE:
Childe Hassam (owned through June 1902, offered for sale at $350); ? ; Stephen P. Mugar, Massachusetts, April 1959; ? .

EXHIBITIONS:
Richmond, Art Association of Richmond, *Sixth Annual Exhibition of the Richmond Art Association, Garfield School Building*, June 10–24, 1902, cat. no. 45.

REFERENCES:
Morton, Frederick W. "Childe Hassam, Impressionist," *Brush and Pencil*, vol. VIII, no. 3, June 1901, pp. 141–50, illustrated, p. 148; Sotheby Parke Bernet Inc., New York, 1959, sale no. 1869, April 1959, lot. no. 51; *Connoisseur*, vol. 143, no. 577, April 1959, p. 121, illustrated.

74. *The Old Violinist* before May 1906
oil on canvas

PROVENANCE:
Childe Hassam (owned through June 1906, offered for sale at $800); ? .

EXHIBITIONS:
Richmond, Art Association of Richmond, *Tenth Annual Exhibition of the Art Association of Richmond, Indiana, Garfield School Building*, June 12–26, 1906, cat. no. 63.

REFERENCES:
Unpublished: Letter dated May 2, 1906, Childe Hassam, 27 West 67th Street, New York, New York, to Mrs. M. F. Johnston, director, Art Association of Richmond, Indiana.

75. *Portland, Oregon* before November 1906
probably oil on canvas

PROVENANCE:
Childe Hassam; ? ; Collier and Co, New York, New York, before November 1906; ? .

EXHIBITIONS:
Indianapolis, Art Association of Indianapolis, The John Herron Art Institute, *Inaugural Exhibition*, November 20–December 31, 1906, cat. no. 91-B.

76. *Children Playing* before May 1907
watercolor on paper

PROVENANCE:
Childe Hassam (owned through May 1907, offered for sale at $650); ? .

EXHIBITIONS:
Muncie, Muncie Art Association, *Second Annual Exhibition of the Muncie Art Association*, May 16–27, 1907, cat. no. 34; Richmond, Art Association of Richmond, *Eleventh Annual Exhibition of the Art Association of Richmond, Indiana, Garfield School Building*, June 11–25, cat. no. 34.

77. *The Rocks of Appledore (Isles of Shoals)* before March 1908
oil on canvas

PROVENANCE:
Childe Hassam (owned through May 1908, offered for sale at $850); ? .

EXHIBITIONS:
Muncie, Muncie Art Association, *Third Annual Exhibition of the Muncie Art Association*, May 14–25, 1908, cat. no. 29; Richmond, Art Association of Richmond, *Twelfth Annual Exhibition of the Art Association of Richmond, Indiana, Garfield School Building*, June 9–23, 1908, cat. no. 55.

REFERENCES:
Unpublished: Letters dated circa March 1908 and April 18, 1908, Childe Hassam, 27 West 67th Street, New York, New York, to Mrs. M. F. Johnston, director, Art Association of Richmond, Indiana.

78. *The Church Spire (Provincetown)* before March 1908
oil on canvas

PROVENANCE:
Childe Hassam (owned through May 1908, offered for sale at $850); ? .

EXHIBITIONS:
Muncie, Muncie Art Association, *Third Annual Exhibition of the Muncie Art Association*, May 14–25, 1908, cat. no. 30; Richmond, Art Association of Richmond, *Twelfth Annual Exhibition of the Art Association of Richmond, Indiana, Garfield School Building*, June 9–23, 1908, cat. no. 56.

REFERENCES:
Unpublished: Letters dated circa March 1908 and April 18, 1908, Childe Hassam, 27 West 67th Street, New York, New York, to Mrs. M. F. Johnston, director, Art Association of Richmond, Indiana.

79. *Northeast Headlands, New England Coast* 1901
oil on canvas
64.1 × 76.7 cm, 25 1/8 × 30 1/8 inches
signed in oil paint, lower right: Childe Hassam 1901

PROVENANCE:
Childe Hassam; The Corcoran Gallery of Art, Washington, D. C., by December 1908.

EXHIBITIONS:
Indianapolis, Art Association of Indianapolis, The John Herron Art Institute, *Twenty-Fourth Annual Exhibition*, December 6, 1908–January 4, 1909, cat. no. 35; probably Pittsburgh, Department of Fine Arts, Carnegie Institute, *Fourteenth Annual Exhibition*, May 2–June 13, 1910, cat. no. 146.

REFERENCES:
Pousette-Dart, Nathaniel. *Distinguished American Artists: Childe Hassam*, Introduction by Ernest Haskell, New York: Frederick A. Stokes Company, 1922, unpaginated, p. 78.

80. *Autumn in New England* before May 1911
oil on canvas

PROVENANCE:
Childe Hassam (owned through May 1911, offered for sale at $1,500); ? .

EXHIBITIONS:
Muncie, Art Association of Muncie, *Sixth Annual Exhibition of the Art Association of Muncie, Indiana, Ball Block*, May 19-31, 1911, cat. no. 18; Richmond, Art Association of Richmond, *Fifteenth Annual Exhibition of the Art Association of Richmond, Public Art Gallery, High School Building*, October 10-29, 1911, cat. no. 18.

REFERENCES:
Possibly, American Art Galleries, American Art Association. *Catalogue of Oil Paintings, Water Colors, and Pastels by Childe Hassam*. New York: American Art Association, 1896, sale, February 6-7, 1896, lot no. 69.

81. *The Shoals Rocks* before May 1911
probably oil on canvas

PROVENANCE:
Childe Hassam (owned through May 1911, offered for sale at $650); ? .

EXHIBITIONS:
Muncie, Art Association of Muncie, *Sixth Annual Exhibition of the Art Association of Muncie, Indiana, Ball Block*, May 19-31, 1911, cat. no. 19; Richmond, Art Association of Richmond, *Fifteenth Annual Exhibition of the Art Association of Richmond, Indiana, Public Art Gallery, High School Building*, October 10-29, 1911, cat. no. 19.

82. *East Hampton Street* before October 1920
(*Street in East Hampton*)
oil on canvas
46 × 38.3 cm, 18 × 15 inches

PROVENANCE:
Childe Hassam (consigned to William Macbeth, Inc., October 22, 1920; consigned by Macbeth to Carson, Pirie and Scott, Chicago, Illinois, May 18, 1921; Gillespie, April 25, 1922; Albright Art Gallery, Buffalo, New York, April 1923; Faregil Galleries, New York, New York, May 7, 1923; Macon, March 1924; Cincinnati, May 1924; ? , December 28, 1924); William Macbeth, Inc., New York, New York, April 1925 (consigned to Southhampton, August 18, 1927; ? , October 8, 1927; ? , March 1928; A. & E. Milch Galleries, Inc., New York, New York, December 19, 1928); ? , December 1928; ? .

EXHIBITIONS:
Muncie, Muncie Art Students League, *Exhibition of Paintings by Contemporary American Artists Loaned by the Macbeth Galleries, New York, Engaged by The Art Students League in the Central High School*, March 1925, cat. no. 20.

REFERENCES:
Unpublished: Stock disposition cards—sold pictures, William Macbeth, Inc., New York, New York, no. 222.

83. *Wet Day, Fifth Avenue* before March 1925
oil on canvas

PROVENANCE:
Childe Hassam; William Macbeth, Inc., New York, New York, before March 1925; ? .

EXHIBITIONS:
Muncie, Muncie Art Students League, *Exhibition of Paintings by Contemporary American Artists Loaned by the Macbeth Galleries, New York, Engaged by The Muncie Art Students League in the Central High School*, March 1925, cat. no. 21.

84. *Marche St. Pierre, Montmartre* 1888
oil on canvas
46 × 33 cm, 18 × 12 7/8 inches (#8 paysage)

PROVENANCE:
Childe Hassam; William Macbeth, Inc., New York, New York, February 1929; Mr. & Mrs. George A. Ball, Muncie, Indiana, March 1929 (consigned to William Macbeth, Inc., New York, New York, March 22, 1938); Bartlett Arkell, New York, New York, March 25, 1938; Louise Ryals Arkell (widow), New York, New York, May 10, 1951; ? .

EXHIBITIONS:
New York, William Macbeth, Inc., *Exhibition of Paintings by Childe Hassam, N. A., Covering the Period 1888-1919, Together with Etchings, Watercolors and Pastels*, April 1929, cat. no. 18.

REFERENCES:
Unpublished: Stock disposition cards—sold pictures, William Macbeth, Inc., New York, New York, #4417; invoice dated July 1, 1929, William Macbeth, Inc.; stock disposition cards—sold pictures, William Macbeth, Inc., #9578 (old no. 4417); estate of B. Arkell, "Disposition of the Residue of Paintings at 15 W. 10th Street, New York, New York to the Canajoharie Library and Art Gallery; The Arkell Hall Foundation, Inc., A Home for the Aged in Canajoharie; and to His Widow Louise Arkell." Schedule C, no. 2.

Letters

Letter postmarked New York, October 29, 1901, 12:30 A.M.

Mrs. G. A. Ball[1]
Muncie, Indiana

139 West 55th Street
New York October 28th 1901

Dear Madam

Pray pardon my delay in answering your note of October 11th asking for a picture for your exhibition.[2]

I cannot promise you anything from the Pan American Exposition unless it is the "Summer" and I am not sure of that but you can ask for it and if I haven't promised it somewhere else you will get it.[3]

I know that it is not sold and that is the only thing that I am quite sure of—. I have promised so many—

Later if you like I think I can have something for your exhibition.

Yours very truly
Childe Hassam

[1]Mrs. George A. Ball was one of the founding members of the Art Students' League and one of the principal organizers of its 1902 exhibition.
[2]A reference to the Art Students' League *Annual Exhibition*, January 27–February 4, 1902.
[3]*Summer* (catalogue no. 72, p. 63) was included in the 1902 Muncie exhibition.

George and Frances Ball Foundation

Letter

139 West 55th Street
N. Y. Dec 1st 1901
Mrs. G. A. Ball

Dear Mrs. Ball

You may have the Summer if I still possess it two-months from now—and if I can I will send another smaller one.[1] The size of the canvas is 20 x 24 and I should send nothing larger than that so that your estimate of space will be simple—

> *Yours Truly*
> *Childe Hassam*

[1]Whether the second, smaller canvas was forthcoming remains a mystery. No exhibition catalogue was published, and the review of the exhibition that appeared in *The Muncie Evening Times*, January 27, 1902, does not mention a second work.

George and Frances Ball Foundation

Letter

27 w 67th St.
May 2nd 1906

Dear Mrs. Johnston:[1]

The watercolors you mention are in the American Watercolor Society which opens tomorrow here in New York.
I have an oil "The Old Violinist" The figure of an old man walking along by the Park wall in winter.[2] *I ask eight hundred for it—if your committee did me the honor to choose it for the Rick fund they could have it at that price or the amount of the fund.*

Yours Very Truly
Childe Hassam

N. B.
Please instruct your agent—or shall I have the Artists Packing & Shipping Co. come for it—

[1]Mrs. M. F. (Ella Bond) Johnston, founding director of the Whitewater Valley Museum of Art (Art Association of Richmond), Richmond, Indiana.
[2]*The Old Violinist* (catalogue no. 74, p. 64) was included in the *Tenth Annual Exhibition of the Art Association of Richmond*, June 12–26, 1906, organized by Mrs. Johnson.

Whitewater Valley Museum of Art (Richmond Art Association)

Letter, circa March 1908

My Dear Mrs. Johnston;

My pictures must be insured. I cannot send them under any other conditions—why should I? I have a law suit on one with a dealer in Denver Col—who lost one of my canvases—Why should I be 1000—out—While helping to educate the Daniel G. Ricks of the West—who has money enough to buy one of my canvases and get aquainted with it.

When they really know one of them you could not get it away from them, with—well with a western trolley car hitched up to it! I will try the marine on you as I still have it—just this once insurance is not dear—[1]

Sincerely
Childe Hassam.

[1]The marine entitled *The Rocks of Appledore (Isles of Shoals)* (catalogue no. 77, p. 64), was included in the *Twelfth Annual Exhibition of the Art Association of Richmond*, June 9–23, 1908, and in the *Third Annual Exhibition of the Muncie Art Association*, May 14–25, 1908.

Whitewater Valley Museum of Art (Art Association of Richmond)

Postal Card postmarked New York, New York, April 18, 1908, 11 A.M.

Mrs. M. F. Johnston
Art Association
Richmond, Indiana

27 w 67th

Dear Mrs. Johnston,

> *I have no blank—but this will serve—I found a marine in Boston.*
>> *The Church Spire—Provincetown 850*
>> *The Rocks of Appledore—Isles of Shoals 850[1]*
> *These canvases are at the shippers now—AP & S Co.*
> *AM*
> *April 18th 1908*

>> *Yours Truly*
>> *Childe Hassam*

[1]Both works (catalogue nos. 77 & 78, p. 64 were included in the *Twelfth Annual Exhibition of the Art Association of Richmond*, June 9-23, 1908, and the *Third Annual Exhibition of the Muncie Art Association*, May 14-25, 1908.

Whitewater Valley Museum of Art (Richmond Art Association)

Selected Bibliography

An asterisk to the left of an entry indicates a volume containing a comprehensive bibliography.

Adams, Adeline. *Childe Hassam.* New York: American Academy of Arts and Letters, 1938.

Archives of American Art. *Collection of Exhibition Catalogues.* Boston: G. K. Hall, 1979.

Buckley, Charles E. *Childe Hassam: A Retrospective Exhibition.* Washington, D. C.: The Corcoran Gallery of Art, 1965.

Cortissoz, Royal. *The Etchings and Drypoints of Childe Hassam, N. A.* New York: Charles Scribner's Sons, 1925.

Czestochowski, Joseph S. "Childe Hassam Paintings from 1880 to 1900," *American Art Review,* vol. 4, no. 4, January 1978, pp. 40–51, 101.

*Gerdts, William H. *American Impressionism.* Seattle: The Henry Art Gallery, University of Washington, 1980.

_____. *American Impressionism.* New York: Abbeyville Press, 1984.

Griffith, Fuller. "The Lithographs of Childe Hassam: A Catalogue," *Smithsonian Institution, United States National Museum, Bulletin 232,* Washington, D. C.: Smithsonian Institution, 1962.

Griner, Ned. *Side By Side with Coarser Plants: The Muncie Art Movement, 1885–1985.* Muncie, Indiana: Ball State University, 1985.

*Haley, Kenneth. "The Ten American Painters: Definition and Reassessment," Ph.D. dissertation, State University of New York at Binghamton, 1975.

Hoopes, Donelson F. *Childe Hassam.* New York: Watson-Guptill, 1979.

Leonard Clayton Gallery. *Handbook of the Complete Set of Etchings and Drypoints of Childe Hassam, N.A.* Introduction by Paula Eliasoph. New York: Leonard Clayton Gallery, 1933. (The Archives of American Art microfilm collection includes a copy of this publication corrected and annotated by Childe Hassam.)

McGuire, James C. *Childe Hassam,* vol. 3 of *American Etchers.* New York: T. Spencer Hutson; London: P. & D. Colnaghi, 1929.

Pousette-Dart, Nathaniel. *Distinguished American Artists: Childe Hassam.* Introduction by Ernest Haskell. New York: Frederick A. Stokes, 1922.

Reynard, Grant. "The Prints of Childe Hassam, 1859–1935," *American Artist,* vol. 24, November 1960, pp. 42–47.

*University of Arizona Museum of Art, *Childe Hassam: 1859–1935.* Essay and catalogue by William E. Steadman. Tucson: University of Arizona Museum of Art, 1972.